IMAGES
of America

CONEY ISLAND
AND ASTROLAND

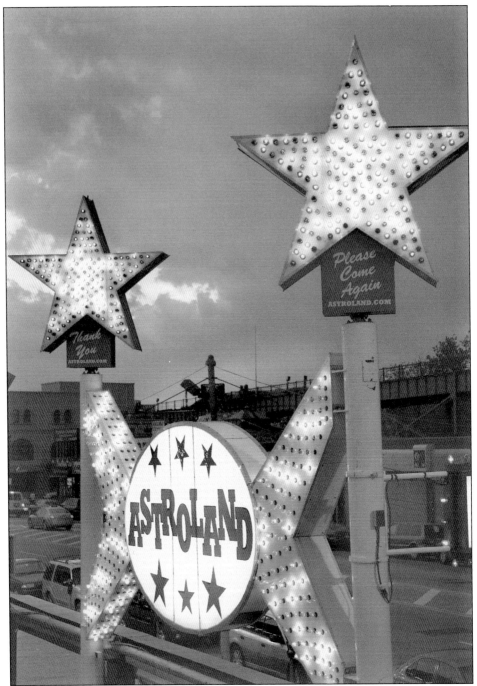

Astroland's Surf Avenue entrance was adorned with two spinning, illuminated stars. After the park closed, one of the stars was donated to the Smithsonian for display in the National Air and Space Museum. (Photograph by Charles Denson.)

ON THE COVER: Astroland's main attractions for the 1964 season were the Skyride, Astrotower, Diving Bells, Moon Rocket, and Satellite Jet Ride. (Courtesy of the Astroland Archive.)

IMAGES of America
CONEY ISLAND AND ASTROLAND

Charles Denson

ARCADIA
PUBLISHING

Copyright © 2011 by Charles Denson
ISBN 978-0-7385-7428-8

Published by Arcadia Publishing
Charleston, South Carolina

Printed in the United States of America

Library of Congress Control Number: 2010935096

For all general information, please contact Arcadia Publishing:
Telephone 843-853-2070
Fax 843-853-0044
E-mail sales@arcadiapublishing.com
For customer service and orders:
Toll-Free 1-888-313-2665

Visit us on the Internet at www.arcadiapublishing.com

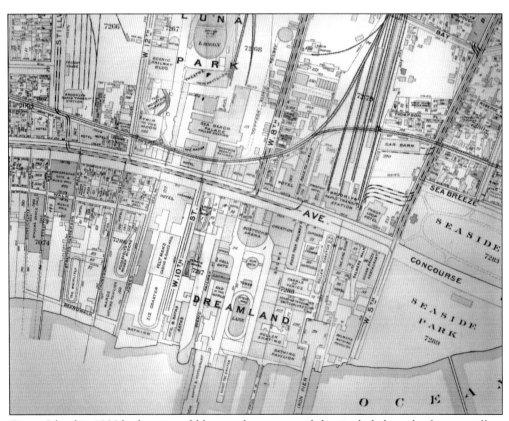

Coney Island in 1908 had an incredibly complex street grid that included a web of narrow alleys and walks connecting Surf Avenue and the beach. Dozens of carousels, roller coasters, dance halls, and hotels competed for business. (Courtesy of the Coney Island History Project.)

Contents

Introduction		7
1.	Coney Island Streetscapes	11
2.	Feltmans and Wonderland	59
3.	Building Astroland	75
4.	Astroland's Journey to the 21st Century	85

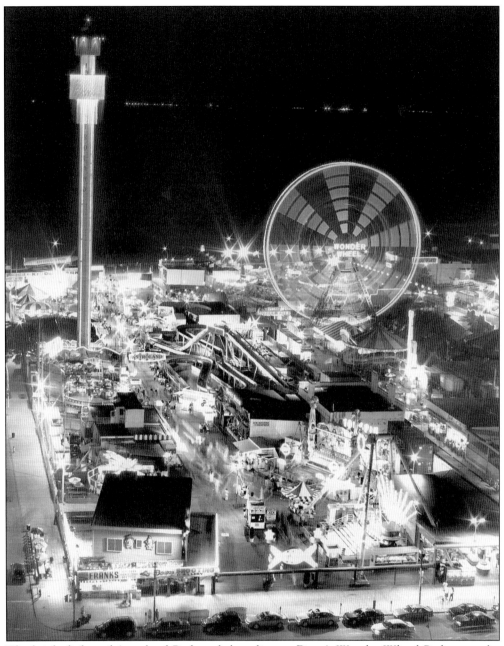

The bright lights of Astroland Park and the adjacent Deno's Wonder Wheel Park created a kaleidoscopic effect at night. The two family-run parks, separated by Jones Walk, were friendly competitors for several decades, and their efforts at improving the amusement zone kept Coney Island afloat through hard times in the 1970s and 1980s. (Photograph by Charles Denson.)

INTRODUCTION

 Lost in the hype surrounding recent redevelopment plans for Coney Island is a fascinating story that has been unfolding for the last 150 years. And that story is the city's attempts to control the sandbar known as the "Playground of the World." A good way to understand the evolution of Coney Island is to focus on the three-acre parcel of land that until recently was known as Astroland Park.
 Astroland Park was created almost by accident, the happy result of a real estate deal that did not come to pass. The park came into existence just when it was needed most and transformed Coney Island's oldest attraction into its newest. Astroland began as an offshoot of the venerable Feltmans Restaurant. German immigrant Charles Feltman's business empire began in 1871 with a small food stand on the sand dunes and grew into a sprawling restaurant that in 1910 was billed as the world's largest, serving more than five million customers a year. Feltman was also considered the inventor of the hot dog. According to legend, he came up with the idea of offering a sausage on a roll to avoid providing silverware or plates to his customers. In 1916, a Feltmans Restaurant roll-slicer and dishwasher named Nathan Handwerker left his job to open his own business a few blocks away on Surf Avenue. His Nathan's 5¢ hot dogs were half the price of those at Feltmans, and his Surf Avenue "grab joint" quickly became an icon synonymous with Coney Island.
 By the early 1950s, Nathan's Famous had expanded numerous times and was quickly outgrowing its Surf Avenue location. Double-parked cars blocked the streets, and hungry throngs clogged the sidewalks. Parking tickets and long lines became an unpleasant part of the Nathan's dining experience. Handwerker realized that he needed to find a larger location in Coney Island that could provide parking, entertainment, and room for further expansion. To do this, he decided to return to his Feltmans roots. The Great Depression and prejudice against German businesses during World War II had taken their toll on Feltmans, and in 1952, the restaurant declared bankruptcy and was put up for sale.
 Handwerker wanted to buy the Feltmans property but feared that his interest would drive up the price. He contacted his friend Dewey Albert, a residential developer who also owned the Fascination Game Arcade in Times Square. The two men had met in the Catskills at a high-powered political function that Handwerker was catering. Handwerker and Albert drew up preliminary plans to buy the Feltmans property, with Handwerker remaining a silent partner. On June 1, 1954, Dewey Albert, Paul Yampol, Adolph Weiss, and Herman Rapps formed a partnership called Coney Island Enterprises and purchased the Feltmans Restaurant property for $490,000 in cash. The partnership's plan called for the three-acre property to be decked with parking below, amusements above, and restaurants along Surf Avenue and on the Boardwalk. The ambitious plan languished for two years before the partnership came to an abrupt end. According to Albert, Handwerker's wife, Ida, wanted her husband to retire and thought his expansion was too complicated. In 1961, Handwerker sold his share in the partnership to Albert, and Nathan's Famous remained at its Surf Avenue location.
 Jerry Albert, fresh out of college and loath to join his father's real estate business, jumped at the chance to convert the sprawling Feltmans Restaurant property into a $3-million world-class amusement park. It took the father-son team two years. In the spring of 1964, the media jumped aboard the thundering rocket that was Astroland. It was the most exciting thing to happen at

Coney Island since the end of World War II. Jerry and Dewey Albert had created a space-age park with the theme "Journey to the 21st Century."

The Alberts' investment turned out to be the salvation of Coney Island at a low point in its history. The next decade brought the demolition of Steeplechase, a rising crime rate, urban renewal, beach pollution, fires, competition from suburban amusement parks, and a civic neglect that led to a deteriorating infrastructure. Astroland became the anchor for Coney Island, the glue that held it together while many businesses gave up. Perhaps the Alberts' greatest feat was saving the adjacent Cyclone roller coaster after the city had purchased the coaster—and threatened to demolish it for an Aquarium expansion. Dewey Albert and his partners obtained a lease to operate the derelict Cyclone and completely restored it, reopening the ride in July 1975. It would remain the centerpiece of the park for the next three decades.

After Dewey Albert died in 1992, Jerry Albert took over all operations. The future of the park became uncertain when Albert was diagnosed with Parkinson's disease. He briefly considered selling Astroland but instead turned to his wife, Carol, and asked her to operate the park if and when he needed to retire. Carol Hill Albert was a respected writer, editor, and educator but had no experience in the amusement business. "My husband had attempted to train me for several years," Carol remembers, "because he felt strongly that I was the only person his employees would accept. I resisted, but he finally said, 'Either you do it, or we sell the park now.' Neither of us really wanted to sell, and I kept hoping that he would not get sicker. I was in denial that the illness was beginning to wear on him. Then one of the park managers took me aside and said, 'If you don't come in now, it will be too late.' That was a wake-up call, and I was in on Monday morning."

During Carol Albert's tenure, the park become more popular than ever as Coney Island stabilized, expanded, and regained its footing after a long decline. Astroland and the adjacent family-operated Wonder Wheel Park engaged in a friendly competition. Attendance records were broken, new rides added, and a new generation discovered the strange delights of the "People's Playground." Astroland had survived its "journey to the 21st century."

In 2003, the Bloomberg administration announced a massive rezoning project for Coney Island, led by city's Economic Development Corporation. The proposal would reduce the amusement zone and allow 5,000 units of high-rise residential development to be built on and around the former site of Steeplechase Park, an area totaling about 10 acres. Because the Steeplechase site was officially zoned as city parkland, the EDC needed to provide an equal area of parkland to replace it at another site. The site that the EDC chose was Coney Island's Boardwalk amusement zone, an area that was privately held.

Shortly after the rezoning plan was announced, an orgy of real estate speculation began. Shopping-mall developer Thor Equities began buying up property in the heart of the amusement zone, paying above-market value to acquire key lots from Surf Avenue to the Boardwalk. A condominium developer paid $95 million for a lot adjacent to the Steeplechase site that had sold to Thor for $13.5 million only a year before. The city administration had made it clear that part of the plan was to have a single operator for Coney Island's amusements. It seemed as if the days of Coney Island's independent operators might be coming to an end.

The entity charged with implementing the mayor's 2005 Strategic Plan was the Coney Island Development Corporation. The CIDC's board members were supposed to represent the interests of the community, but locals were shocked to learn that no one from the amusement business had been named to the board. This oversight sent a not-so-subtle message to the current amusement owners that they were not going to be included in the "new" Coney Island. Many longtime operators became suspicious of the city's plan and were reminded of the "scorched earth" policies of power-broker Robert Moses, who decades before had declared Coney Island an urban-renewal area and proceeded to condemn and acquire the entire west end of the island through eminent domain. Moses's "master plan" had nearly killed Coney Island.

As Coney Island's largest private landowner, Carol Albert was in a quandary. She had been upgrading the park for years and was planning a major capital outlay but did not know how

Astroland's three acres would be affected by the rezoning. The city's numerous public meetings and PowerPoint presentations only added to the confusion. Abstract renderings and vague assurances did not make clear whether the Albert family's property would receive the same zoning as the adjacent properties being purchased by speculative developers.

"I went to a meeting at the community board, and during the city's slide show, Astroland was shown covered with green trees labeled Astro Gardens," Albert remembers. "I raised my hand and said I thought it was curious that my property was shown as trees and parkland when nobody had spoken to me about that. It was out of place that this plan was shown in a public meeting place. The people from the city appeared to be quite embarrassed and said the architect (or whoever had done the drawing) had made an error. That may have been the case, but it set off a bell: What is going on here? Is this in fact the city's plan?"

In May 2005, a coalition of business owners sent a letter to the city asking that the amusement area be expanded instead of reduced and providing a financial analysis of the amusement industry. A meeting was called at Coney Island USA, where officials from the EDC were expected to address the coalition's issues, but the subject of the letter was ignored. When the EDC officials were asked how they expected to execute their plan when developer Thor Equities was buying up most of the amusement zone, one official replied that the city had worked with Thor in the past and that the EDC did not foresee a problem.

As the city pushed its massive redevelopment forward, Albert came up with a plan for Astroland that matched the city's proposal to turn Coney into a year-round attraction. "Astroland was at a point where we were considering expanding the park and buying new rides, and it was time for a big capital investment," Albert says. "So I thought, 'If the city wants my property developed, why don't I do it myself?' I hired an architect, Fred Bentel, and his wonderful design kept most of the existing park and included a hotel and restaurant structure on the Boardwalk with water slides and a community pool and was linked to the Aquarium. My plan provided for a lot of jobs, some year-round, which the city rightly demanded in its own plan. I had the financing in place and partners who were very eager." Albert presented her plan to city officials at various meetings but was disappointed by the lukewarm interest. "I was very disappointed," she says, "by what I can only call a lack of commitment. Later, some officials said there had been a series of misunderstandings. I don't know exactly what happened."

Albert had refused an offer from Thor Equities the year before. "When Thor called, I told them that I love the business, that the park had been in the family for years, and that I did not want to sell." By the time Thor came back a second time the following year, she was very discouraged about the chances for her own plan. "It was one of the most difficult decisions I have ever made. The park had been in the family for years, and memories of my father-in-law and my husband were woven into the fabric of the park. Family members had visited regularly and sometimes worked at the park. The business was strong financially, but I felt very vulnerable in the face of the city's proposed changes. Intellectually, I felt I had to sell. Emotionally, it was painful."

The sale of the Astroland site to Thor Equities for $30 million was announced on November 28, 2006. The land was sold with the stipulation that Astroland lease the site and reopen for the 2007 season. The lease was renewed for the following year but not for the 2009 season. Astroland Park closed for good on September 7, 2008.

After years of lobbying and political arm twisting, and despite the protests of advocates who wanted the amusement zone expanded instead of reduced, the rezoning of Coney Island was passed by the New York City Council on July 29, 2009. The residential component of the plan allows 30 high-rise towers, as tall as the Parachute Jump, to be constructed in and around what was formerly zoned only for amusements or parkland. The Bloomberg administration eventually bought six acres of Thor Equities' land, including the Astroland site, at an inflated price of nearly $100 million and forged ahead with the city's plan to create a year-round amusement zone leased to a single operator.

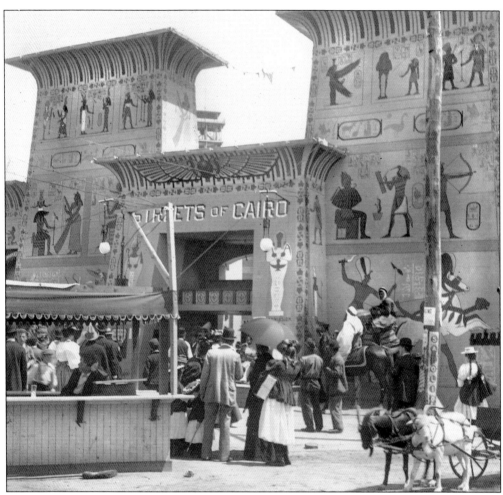

The entrance to the Streets of Cairo exhibit on Surf Avenue and West Tenth Street in 1900 displayed one of the more exotic facades on a street that was known for the unusual. Well-dressed visitors crowded Cairo's Midway Plaisance, a narrow walk that offered a variety of theatrical carnival concessions. The concept was taken from the Columbian Exposition of 1893 and was a frequent target of reformers who protested the "indecency" of the scantily clad dancers who were the main attraction. (Courtesy of the Denson Archive.)

One
Coney Island Streetscapes

Surf Avenue is a thoroughfare like no other in New York. For a century and a half, it has displayed an ever-changing facade of unusual structures housing unusual businesses. The avenue's sweeping curves follow the original shoreline as it existed in the 19th century when the avenue began as an unpaved track through Coney Island's sand dunes, connecting the center of the island to the steamboat pier at its west end.

Coney's history can be best studied by examining images of Surf Avenue's architectural evolution from its early mining-camp tumbledown shacks and shanties to its early-20th-century pseudo-rococo stage-set architecture. Railroad terminals, steamboat piers, and grand boulevards all connected to Surf Avenue. Formal plazas abutted simple, wood-framed clapboard structures that were dwarfed by adjacent spider webs of steel. Complex whirling machines were surrounded by towers, domes, minarets, decorative arches, tents, faux castles, banners, and flags. There was even a 16-story hotel in the shape of an elephant. Surf Avenue's frontage offered a kinetic landscape of visual delights that was unprogrammed, whimsical, and limited only by the creativity and vision of the individual business owner.

Coney Island's hard urban grid was imposed upon soft dunes. The boundary lines were invisible, which has confused many visitors who considered Coney Island a single entity or amusement park. Until recently, it was a neighborhood of small businesses. An August 1938 article in *Fortune* magazine described Coney Island as "more than 500 separate enterprises in violent and continual conflict—perhaps the greatest concentration of independent little businesses in the world."

When the Boardwalk opened in 1923, it replaced Surf Avenue as Coney's main street. During the Roaring Twenties, buildings with strikingly beautiful, nautical-themed terra-cotta facades were erected along this new frontage—only to be demolished when Robert Moses had the Boardwalk moved inland in 1941. The landmarked Child Restaurant Building is the only surviving example of that optimistic period in Coney Island's history. A mere handful of historic 19th-century buildings managed to withstand natural disaster and urban renewal and survive into the 21st century. After the city rezoned Surf Avenue for high-rise hotels in 2009, the survivors were slated for demolition by shopping mall developer Thor Equities. Small businesses were also threatened by the city's redevelopment, and in 2010, several longtime, iconic mom-and-pop Boardwalk businesses that had been open for nearly half a century received two-week eviction notices. The days of the small-time operator in Coney Island were rapidly coming to an end.

Coney Island's first structure, built in 1823, was the Shell Road tollhouse, located at the bridge over Coney Island Creek. The toll was 5¢ for a horse and rider. Shell Road was the first road to Coney Island and was paved with shells excavated from local Indian shell mounds. The tollhouse was demolished in 1928 when Shell Road was widened. William Mangels, whose amusement factory was a block away on West Eighth Street, salvaged the original wooden toll sign and put it on exhibit at his short-lived amusement museum. Today, the 170-year-old sign, often described as Coney Island's first admission ticket, belongs to the Coney Island History Project and is on display at the organization's exhibit center. (Courtesy of the Denson Archive.)

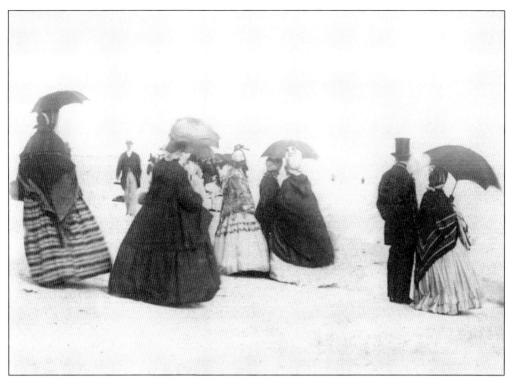

Coney Island beach attire in the 1860s included top hats, bonnets, parasols, and full-length dresses. Sunbathing was unheard of, and ocean swimming remained a novelty for most visitors. (Courtesy of the Denson Archive.)

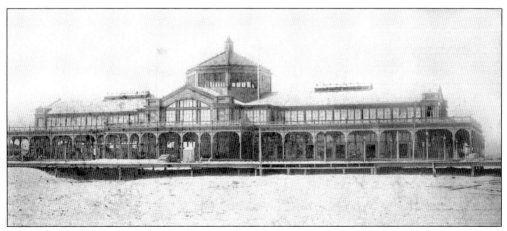

After the close of the Philadelphia Centennial of 1876, the Sea Beach Palace was dismantled and relocated to what is now the intersection of Surf Avenue and West Eighth Street. It served as a hotel and the terminal for the Sea Beach Railroad and later as a roller rink. The palace became incorporated into Luna Park and was demolished in 1924 to make way for a swimming pool. (Courtesy of the Denson Archive.)

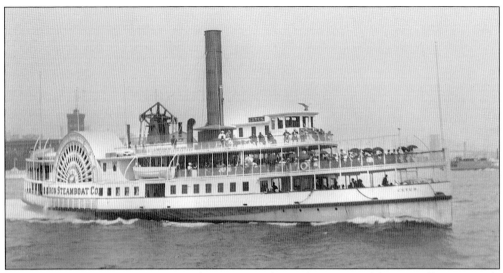

The Iron Steamboat Company's vessel *Cetus*, one of seven boats named for constellations, made scheduled runs from Manhattan to Coney Island's Iron Pier beginning in 1881. Steamboats first began service to Coney Island's Norton's Point in 1845 and continued service to various beachfront piers until the 1930s. (Courtesy of the Denson Archive.)

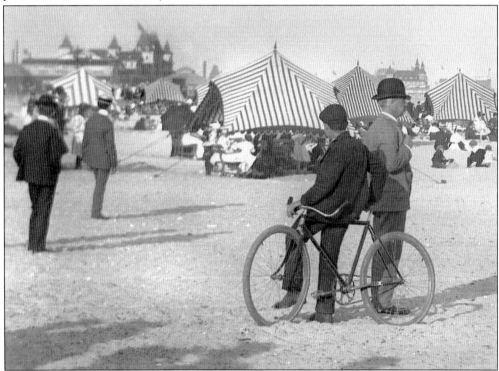

The first bike path in the United States opened on Ocean Parkway in 1894, connecting Prospect Park and Coney Island. The 5.5-mile path ended at two rustic timber beachfront pavilions across from Seaside Park that were used by the "wheelman clubs," whose members parked there for the day. Concessions along Surf Avenue provided bike parking and repair. (Courtesy of the Denson Archive.)

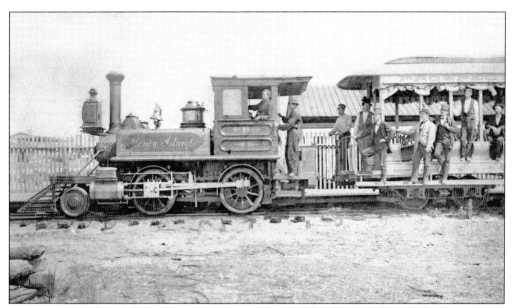

Andrew Culver founded the Prospect Park and Coney Island Railroad in 1875. Here, a small steam locomotive arrives at the Culver Terminal on Surf Avenue. The Culver line was eventually incorporated into the New York City transit system and today operates as the F line. (Courtesy of the Denson Archive.)

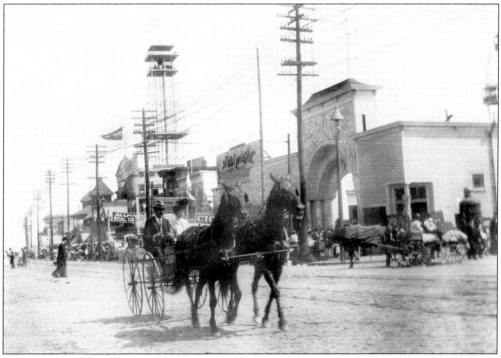

When the last leg to the beachfront was completed in 1880, Ocean Parkway became a speedway for fancy carriages racing to Coney Island. This vehicle is passing West Eighth Street and Surf Avenue. Most large restaurants and hotels provided stables behind their establishments. (Courtesy of the Denson Archive.)

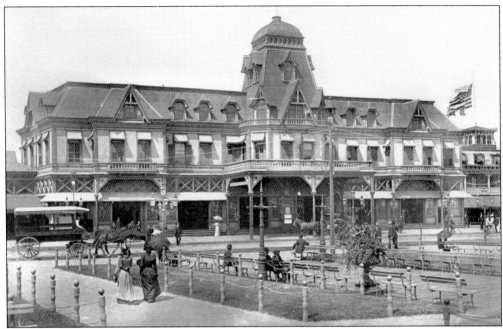

Andrew Culver created this formal plaza in 1875 at the entrance to his railroad terminal. The gaslit plaza had flower gardens, fountains, and wooden paths that led to the Iron Pier. Here, a horse-drawn wagon travels east on Surf Avenue in front of the terminal, which was located at the current site of Brightwater Towers on West Fifth Street. (Courtesy of the Denson Archive.)

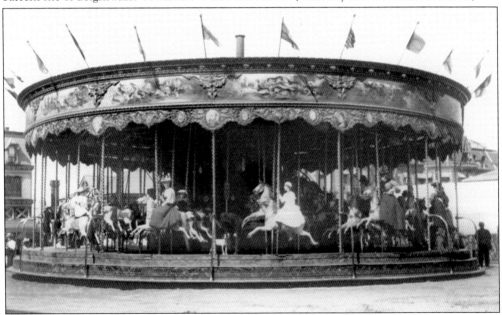

In 1900, this carousel was located at Culver Plaza on the south side of Surf Avenue at West Sixth Street. The factories of famed carousel manufacturers Marcus Illions and William Mangels were just a block away. Coney Island was home to dozens of carousels showcasing the work of Brooklyn carvers Charles Loof, Stein and Goldstein, Charles Carmel, and other artists. (Courtesy of the Denson Archive.)

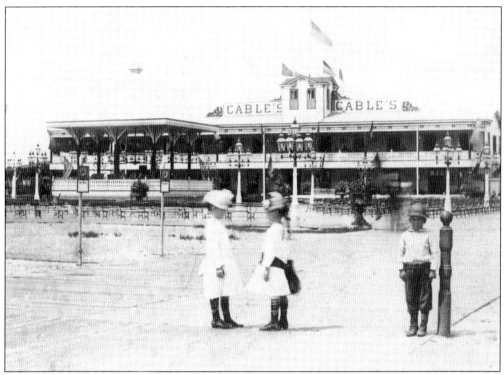

British restaurateur Thomas Cable opened the 150-room Ocean View Hotel on Culver Plaza in 1876. It was famous for its well-stocked wine cellar and for the military bands that played in the band shell at left. (Courtesy of the Denson Archive.)

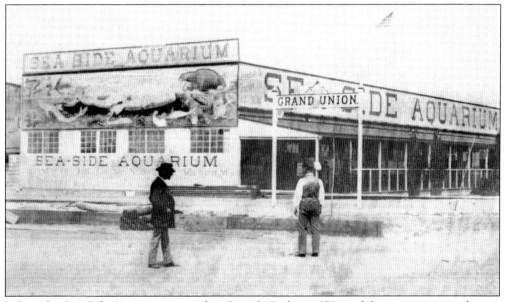

When the Sea Side Aquarium opened in Seaside Park in 1879, its fishy aroma attracted more attention than its aquatic exhibits. The primitive facility did not last long at this location and closed after a short run. The New York Aquarium opened across the street in 1957 after being evicted from its longtime home at Battery Park in Manhattan. (Courtesy of the Denson Archive.)

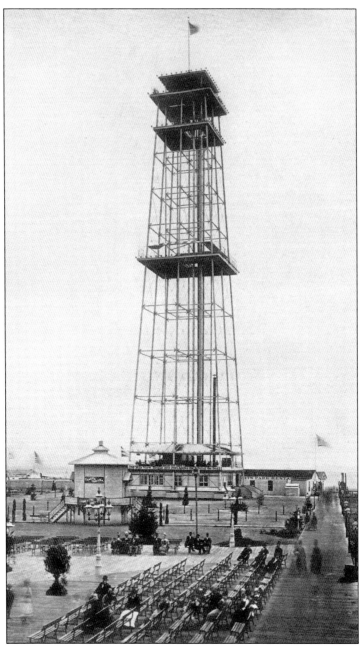

The 300-foot Iron Tower became the tallest structure in the state of New York after it was moved to Culver Plaza from the Philadelphia Centennial in 1877. It had steam-powered elevators that lifted passengers to an observation deck where telescopes offered a sweeping 30-mile-wide view of New York and the Atlantic Ocean. Andrew Culver also installed a camera obscura, the small octagonal building at the lower left. George C. Tilyou leased the tower in 1898 and installed billboards advertising his Steeplechase Amusement Park. The tower buckled and collapsed in the 1911 Dreamland fire. When the Aquarium began excavations for a new building in 2005, the tower's brick foundation, resting on a crib of massive pine timbers, was discovered. (Courtesy of the Denson Archive.)

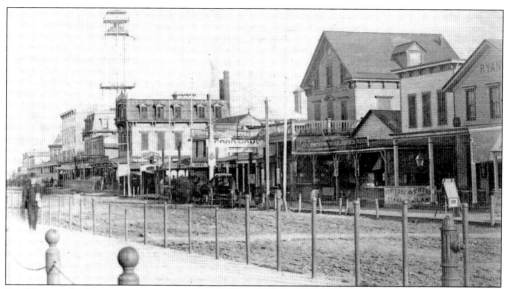

Surf Avenue had a western mining-camp look in the 1880s. The south side of the street offered the Baby Elephant Restaurant, Ryan's, and Gus Samuel's Good Home Hotel. The landmark Grashorn building can be seen in the background, just below the Iron Tower. It is the only structure still surviving to this day. (Courtesy of the Denson Archive.)

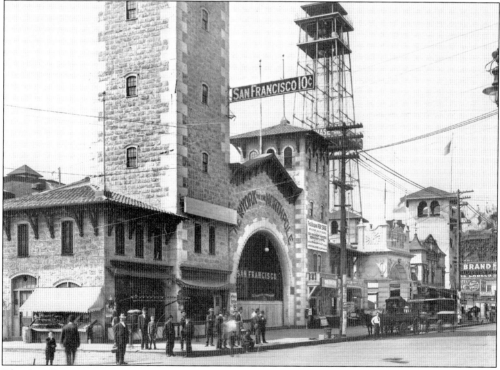

The San Francisco 1906 earthquake and a trip to the North Pole were dramatically re-created in panoramas in this building at West Fifth Street and Surf Avenue. The arched entranceway to Balmer's Baths is at right. The Municipal Baths would later be constructed on this site in 1911. (Courtesy of the Denson Archive.)

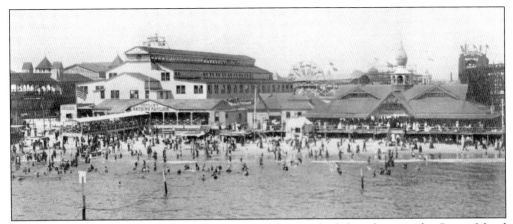

The large barnlike building at left is Paul Bauer's Casino, which later became the Coney Island Athletic Club, where the first indoor heavyweight championship fight was held on June 3, 1899. Bauer also built the nearby Atlantic Garden Hotel in 1876, Coney's largest resort at that time. In the background is the Tilyou Ferris wheel on West Tenth Street. (Courtesy of the Denson Archive.)

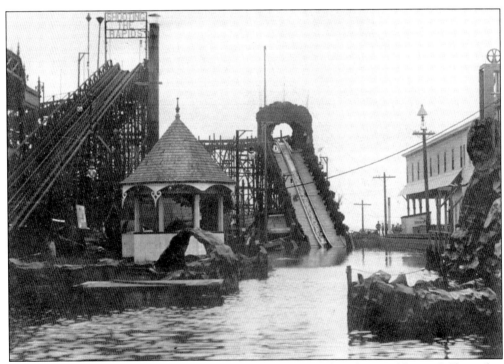

Stephen Jackman's Shooting the Rapids was a toboggan coaster based on Paul Boyton's Shoot-the-Chutes. Jackman was an early coaster designer whose other Coney coasters included Jackman's Thriller, the Whirlwind, and the Musical Railroad. Dreamland's lagoon was later built on this site in 1904. (Courtesy of the Denson Archive.)

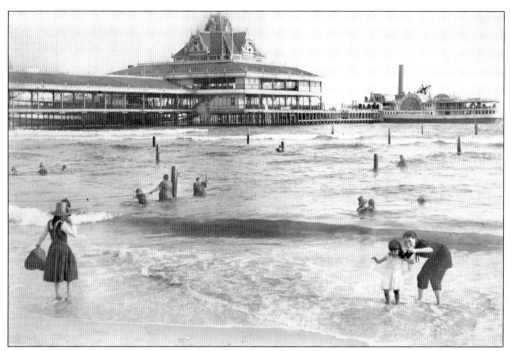

A paddle-wheel steamboat docks at the Iron Pier. There were two Iron Piers at Coney Island, located side-by-side and offering ballroom dancing, restaurants, bathhouses, and theaters. The boats provided transportation to Coney Island until 1932. They operated at the Steeplechase pier after the 1911 Dreamland fire destroyed the Iron Pier. (Courtesy of the Denson Archive.)

Unlike modern swimsuits, Victorian beachwear left a lot to the imagination. (Courtesy of the Denson Archive.)

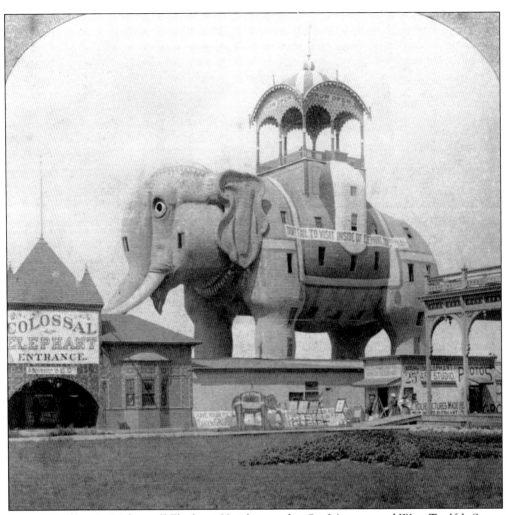

James V. Lafferty's 176-foot-tall Elephant Hotel opened at Surf Avenue and West Twelfth Street in August 1884. Lafferty, a real estate speculator, had erected smaller structures in New Jersey, but this one was his triumph. A brochure at the time described it as "Coney's Colossus: The Eighth Wonder of the World." One of the beast's legs contained a cigar store and another a circular staircase providing access to the 30-odd hotel rooms located in the elephant's belly. An enormous howdah perched on its back served as an observatory. The tin-skinned elephant, with its glowing red eyes, rose above and stood out from the ramshackle brothels, saloons, and dance halls of the surrounding area. A visit to the beast also carried particular symbolism. The phrase "seeing the elephant" became a Victorian euphemism for the erotic offerings available at Coney Island. The Elephant Hotel went up in flames in 1896. (Courtesy of the Denson Archive.)

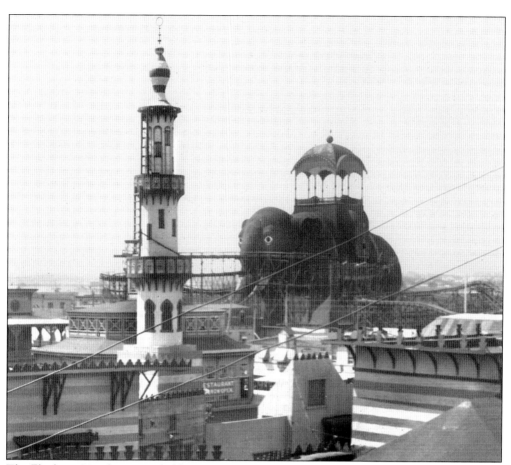

The Elephant Hotel, surrounded by a roller coaster added shortly before the hotel burned, loomed up behind Feltmans Restaurant and the Streets of Cairo exhibit on Surf Avenue. This surrealistic view greeted passengers arriving at the Iron piers across the street. (Courtesy of the Denson Archive.)

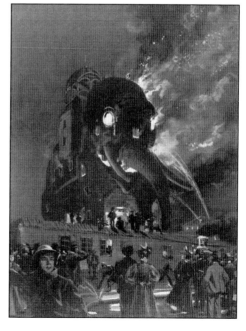

Sheets of flame shooting from the eyes and mouth of the wood-frame Elephant Hotel created a dramatic spectacle before the tin-covered creature collapsed in on itself during the fire of 1896. The site later became the entrance to Luna Park. (Courtesy of the Coney Island History Project.)

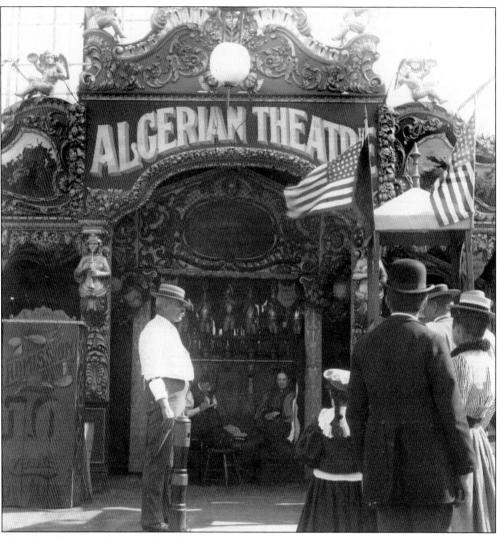

The cherub-covered, ornate facade of this mysterious theater on the Midway Plaisance gave no clue as to what sort of performances awaited customers. The signs promised a "Congress of Beauty" and "20th-Century Girls." Numerous "oriental" dance houses promoting scandalous exotic performances sprang up at the turn of the 20th century, earning Coney Island its nickname of "Sodom by the Sea." The ballyhoo for dancer "Little Egypt" proclaimed that "Anywhere else but in the Ocean Breezes of Coney Island, she would be consumed by her own fire! Don't rush! Don't crowd! Plenty of seats for all!" The novelty soon wore off, but Little Egypt's legacy endured long after the Turkish harems folded their tents, gathered their camels, and moved on. (Courtesy of the Denson Archive.)

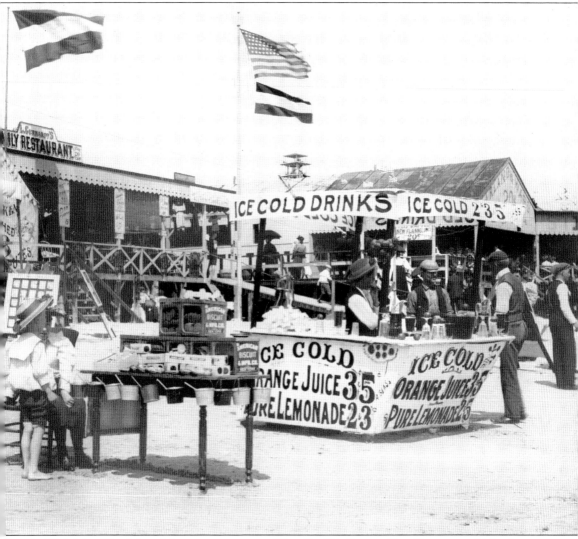

In 1899, John Ward's beachfront concessions at West Twelfth Street offered biscuits, cold drinks, pails, shovels, three-minute tintypes, 15¢ clam chowder, and "all-new flannel swimsuits." Coney's beaches were not public. The sand down to the waterline was private property, and a fee had to be paid at a bathhouse for access to the ocean. Small businesses leased space from the property owners to peddle their wares. (Courtesy of the Denson Archive.)

Hats were a fashion statement in the 1890s. The backdrop in this tintype shows Vanderveer's Hotel and the Iron Tower. Tintype photograph studios were big business in the late 19th century, and no visit to the beach was complete without taking home a souvenir photograph in a small leather case or paper folder. Some studios were set up in tents with fancy painted backdrops, usually generic and unrelated to Coney Island, and some were in tiny storefronts with fancy props like trolley cars or carriages. Street hawkers displayed sample photographs and guided customers into the establishments. The long exposures required for tintypes made outdoor tintype photography very rare. (Courtesy of the Denson Archive.)

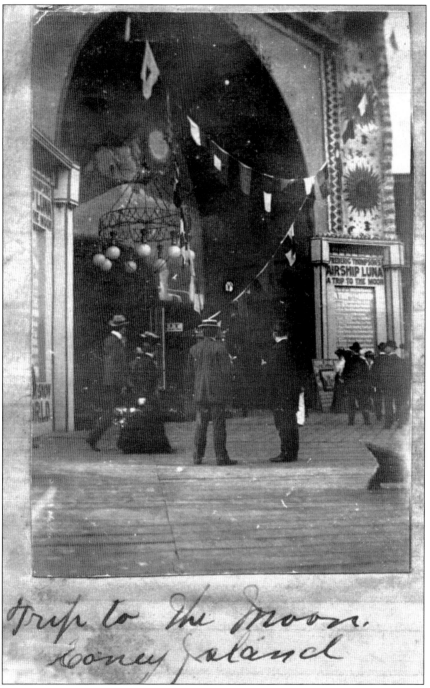

This rare view shows Fred Thompson's Trip to the Moon attraction when it was at Steeplechase Park in 1902. The Air Ship Luna ran for one season at Steeplechase, then was moved up Surf Avenue by elephants and installed at Thompson and Dundy's Luna Park. The Trip to the Moon was a mainstay of the new park and was updated periodically. The ride was an illusion: an imaginary rocket ship landed on a dimly lit moonscape peopled with costumed midgets, who ate green cheese. (Courtesy of the Denson Archive.)

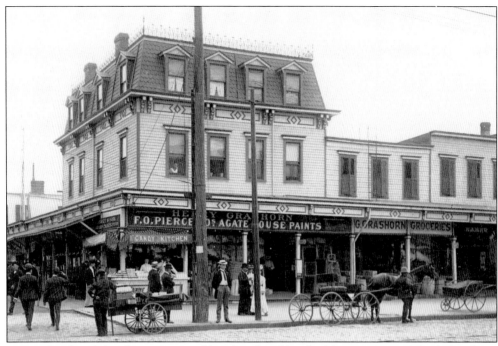

Henry Grashorn's hardware store and hotel is the oldest building in Coney Island. Grashorn provided the nuts and bolts for all Coney's rides and amusements. The structure, built in 1885, survived into the 21st century, when it was sold to a real estate speculator, who threatened to demolish it. (Courtesy of the Denson Archive.)

In 1900, visitors could rent a horse and go riding on the beach. Tents, chairs, and swimsuits could also be rented. (Courtesy of the Denson Archive.)

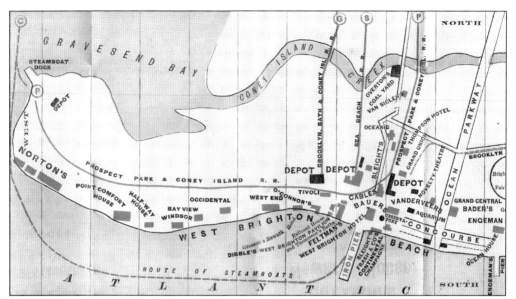

Taunton's map of 1878 shows the attractions at the western half of Coney Island. The businesses listed were the ones that advertised in the guide. The establishments of Coney pioneers William Engeman, Charles Feltman, Tom Cable, and Mike Norton are highlighted. (Courtesy of the Denson Archive.)

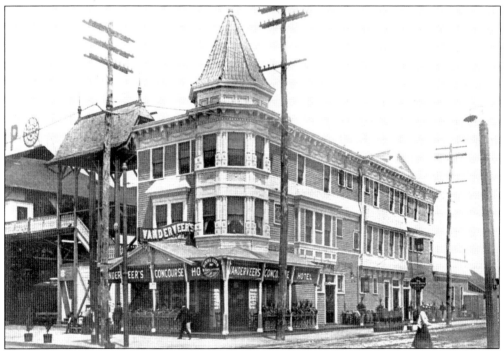

Coney Island pioneers William and Lucy Vanderveer brought the first carousel to Coney in 1876 and placed it beside their hotel on West Fifth Street and Surf Avenue. A smaller version of the Vanderveer Hotel survived alongside the old Culver Terminal until both were demolished in the early 1960s to make way for the Brightwater Towers high-rises. (Courtesy of the Coney Island History Project.)

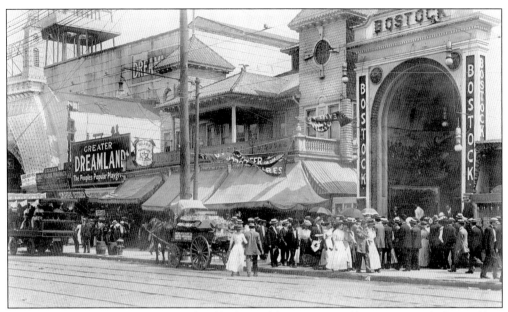

The Surf Avenue frontage of Dreamland had an odd assortment of businesses, including Zeller's Drugstore and George Heppe's Candy Meat Market, which featured sweets in the shape of cuts of meat and cold cuts. A colorful jungle diorama flanked the entrance to Frank Bostock's trained-animal show. (Courtesy of the Denson Archive.)

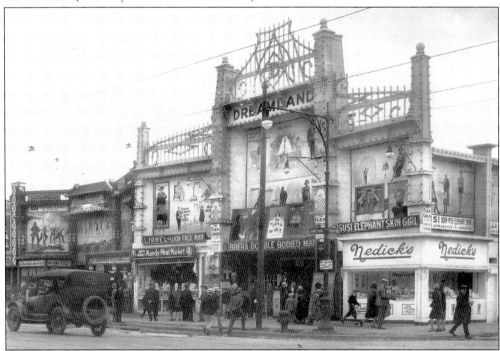

The same Surf Avenue location as above changed over the several years after the 1911 Dreamland fire. Fred Gumpertz's Dreamland Circus Sideshow starred performers Susi the Elephant-Skinned Girl and Lionel the Lion-Faced Man. Next door was the Wax Musée with its "Bandits Morgue." (Courtesy of the Denson Archive.)

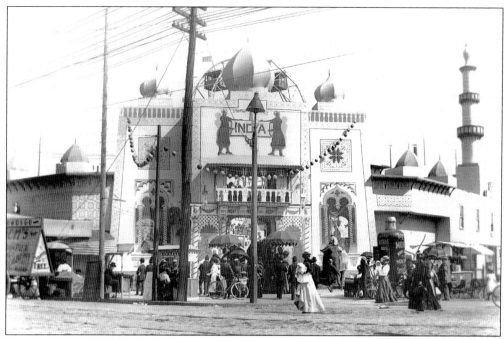

During the 1890s, the corner of West Tenth Street and Surf Avenue displayed a mélange of architectural styles. At the exotic Streets of Cairo attraction, one could ride an elephant or camel, have a palm reading, or see a risqué performance by "couchee-couchee" dancer Little Egypt. (Courtesy of the Denson Archive.)

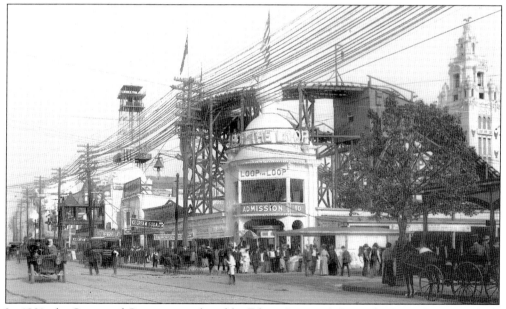

In 1901, the Streets of Cairo was replaced by Edwin Prescott's Loop-the-Loop Coaster, which had a paid observation gallery for those too afraid to ride the coaster. The Iron Tower is at left, and the Dreamland Beacon Tower is at right. This corner was the site of Coney's first coaster, the Switchback Railway, as well as today's landmark Cyclone. (Courtesy of the Coney Island History Project.)

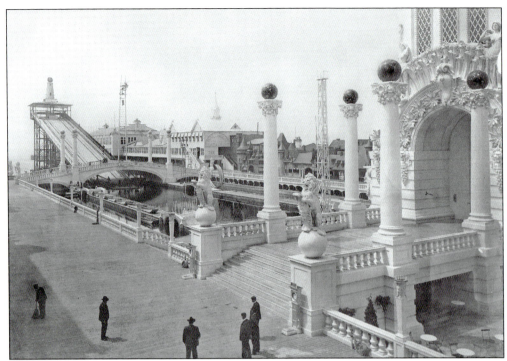

Dreamland's Shoot-the-Chutes and the ornate base of the Beacon Tower were flanked by classical columns and plaster of paris lions. The structures looked solid but in reality were flammable, and none survived the 1911 fire. The Dreamland Ballroom Pier and Midget Village are in the background, behind the lagoon. (Courtesy of the Denson Archive.)

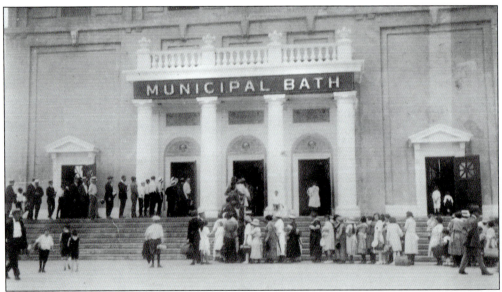

The Municipal Bathhouse opened in 1911 on public parkland at West Fifth Street and Surf Avenue. Private bathhouses charged admission, but the Municipal was free, and the facility's beachfront was public parkland, open to all. The building survived until 1954, when it was demolished to make way for the Aquarium. (Courtesy of the Denson Archive.)

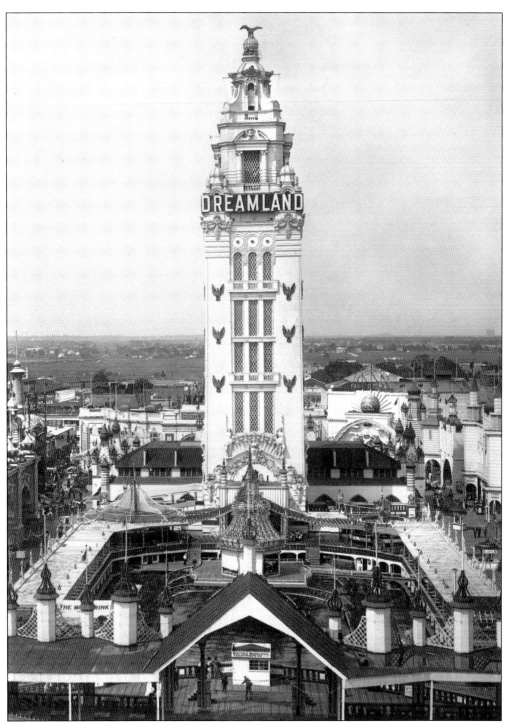

Dreamland's white and gold Beacon Tower rose to a height of 375 feet and was topped by a gigantic eagle perched on an illuminated glass globe. It was the tallest structure in Coney Island until May 1911, when it was consumed by fire and collapsed in a matter of minutes. (Courtesy of the Coney Island History Project.)

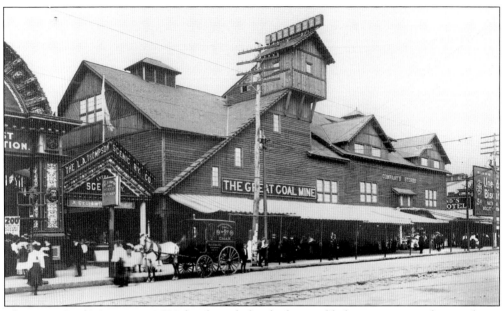

The Great Coal Mine was a 1,500-foot-long dark ride that enabled visitors to travel on coal cars through several levels of a dimly lit simulated mine. It opened in 1901 on the north side of Surf Avenue at West Tenth Street, was not very popular, and was soon replaced by L.A. Thompson's Oriental Scenic Railway. (Courtesy of the Coney Island History Project.)

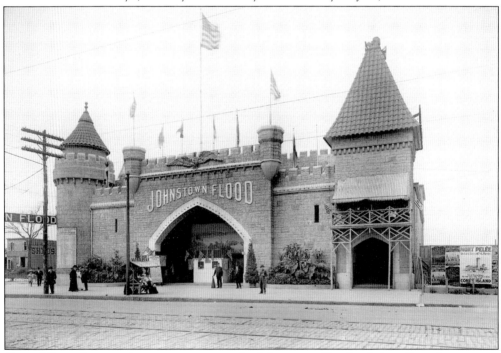

One of Coney's many disaster panoramas, the Johnstown Flood exhibit allowed visitors to experience the devastating deluge of 1889. The spectacle consisted of realistic scenes painted on a rotating backdrop viewed in a darkened auditorium. It was located at Surf Avenue and West Seventeenth Street. (Courtesy of the Coney Island History Project.)

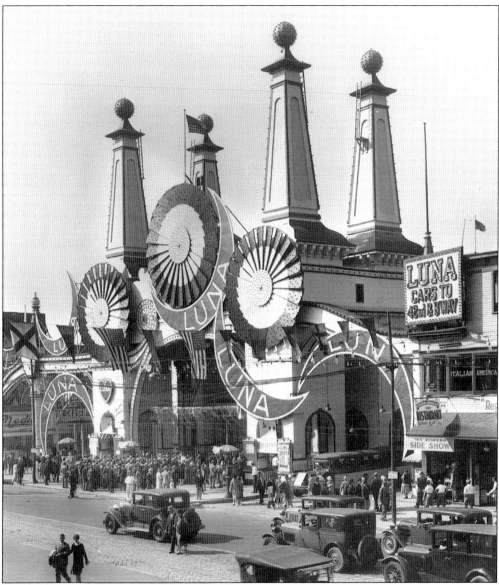

Thompson and Dundy's Luna Park opened in 1903 with a massive arched entrance on Surf Avenue that was later decorated with enormous spinning pinwheels and crescent moons. Among Luna's attractions were hundreds of illuminated towers and minarets, a circus, the Old Mill ride, a scenic railway, Shoot-the-Shoots, and Dr. Martin Couney's infant incubators. At night, the park became the "Electric Eden," illuminated by the radiant glow of 250,000 light bulbs, which outlined every structure. The park closed in the 1940s after a series of fires. The pinwheel and moon motif was later copied for the entrance to the new Luna Park, which opened across the street in 2010. (Courtesy of the Coney Island History Project.)

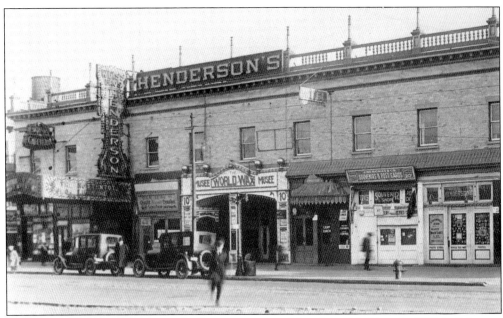

Fred Henderson opened a music hall, restaurant, and hotel in this historic 1899 building at Stillwell and Surf Avenues. Many famous figures, including the Marx Brothers, performed there. The structure survived a devastating fire in 1903 and was rebuilt. Over the next century, the building served as the venue for an array of entertainment, from vaudeville to the World in Wax to the new nightclub, Velocity, which opened in 2003 in a renovated space on the second floor. (Courtesy of the Coney Island History Project.)

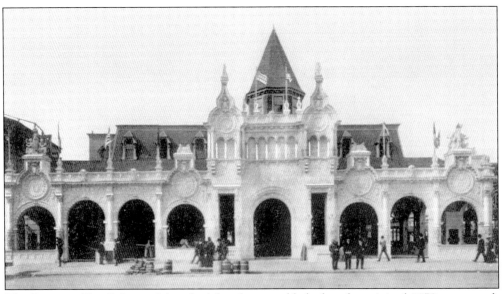

The Prospect Hotel's beautiful arched facade was added after the original 1870s-era wood-framed structure was moved back from Surf Avenue. The hotel stood on the north side of Surf Avenue and West Sixth Street, next to the Culver Terminal. (Courtesy of the Coney Island History Project.)

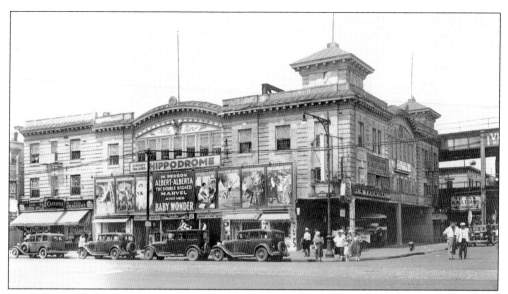

The 1907 Boston Hotel and Theater on West Twelfth Street housed several sideshows and attractions throughout its 70-year span. The Bread and Puppet Theater took up residence there during the late 1960s, when the building was renamed the Lido Hotel. (Courtesy of the Denson Archive.)

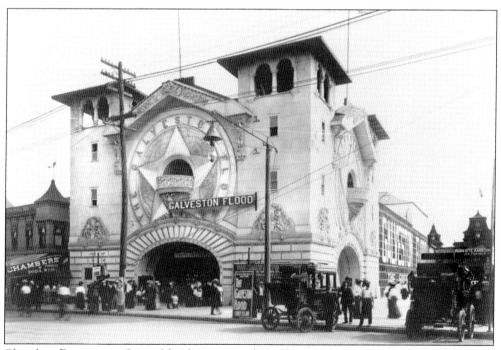

Chambers Drugstore, a Coney Island institution for half a century, was dwarfed by the Galveston Flood building. Located on Surf Avenue at West Fifth Street, the structure survived the 1911 fire and ended its years as a dime museum and arcade. It was demolished to make way for the new Aquarium. (Courtesy of the Coney Island History Project.)

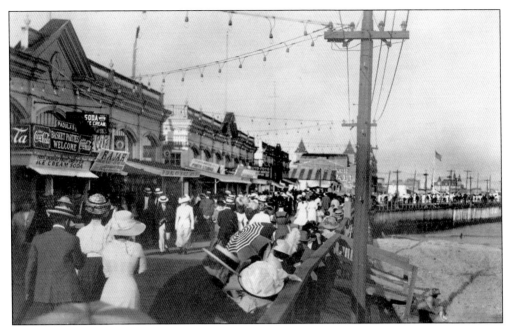

Strollers cruise the Brighton Beach Promenade, heading east from Ocean Parkway toward the Brighton Beach Hotel, around 1910. William Engeman built his Ocean Hotel at this location in 1868 and later opened a racetrack nearby. A large amusement park called Brighton Beach Park operated in Brighton on Coney Island Avenue until it burned in 1918. (Courtesy of the Denson Archive.)

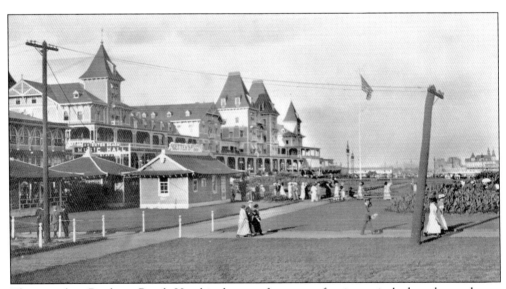

The sprawling Brighton Beach Hotel is shown a few years after it was jacked up, lowered onto flatbed railroad cars, and hauled 500 feet from its eroded beachfront location by a team of steam locomotives. The Manhattan Beach Hotel is in the background at right. (Courtesy of the Denson Archive.)

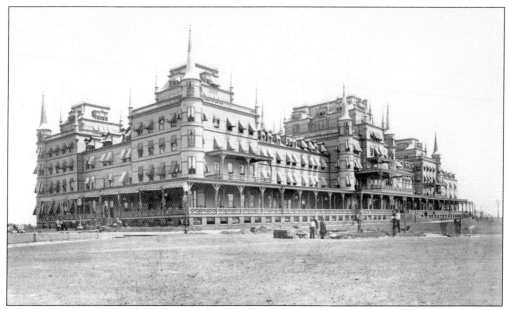

Austin Corbin's Oriental Hotel opened in 1877 at the extreme eastern end of the island and was considered Coney's most exclusive and restrictive establishment. Railroad magnate Corbin was an avowed anti-Semite who sought to ban Jews from his Manhattan Beach businesses. Corbin's Long Island Rail Road provided direct service to his restrictive Manhattan Beach, allowing his visitors to avoid the hoi polloi of Coney Island's West End. (Courtesy of the Denson Archive.)

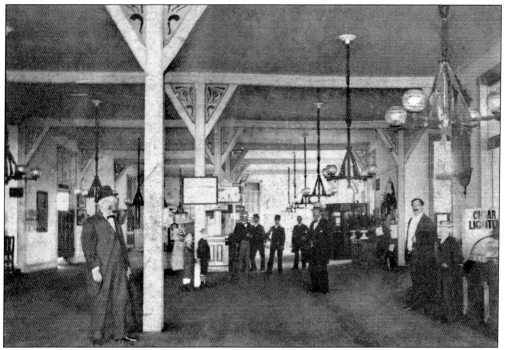

The Brighton Beach Hotel was not as fancy as the Manhattan Beach Hotel or Oriental Hotel, as can be seen in this 1890s photograph of the Brighton's sparse lobby. (Courtesy of the Denson Archive.)

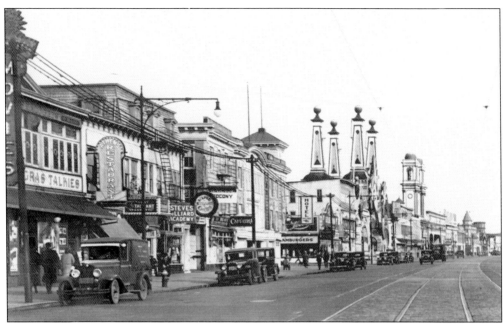

Coney Island had scores of movie theaters, including the Mardi Gras at left, located next to the Stillwell Avenue Subway Terminal. The nearer towers in the background belonged to Luna Park's main entrance, and the distant domed pair of towers marked the entrance to Luna's Palace of Joy. The Mardi Gras burned in the 1940s. (Courtesy of the Denson Archive.)

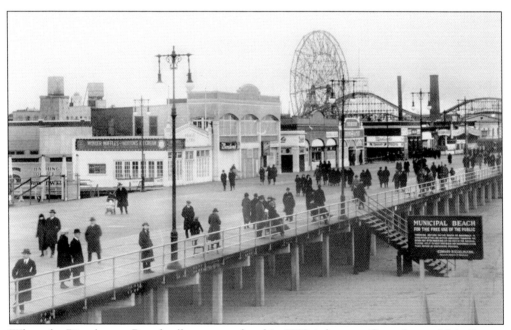

When the Riegelmann Boardwalk was completed in 1923, it became Coney's new Main Street. The Wonder Wheel, built in 1920, and the 1911 Giant Racer Roller Coaster can be seen in the background. (Courtesy of the Denson Archive.)

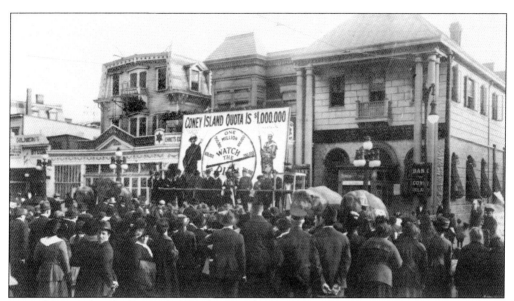

A World War I bond rally was held in front of the Bank of Coney Island at Surf Avenue at West Twelfth Street. Coney pioneer John Ward founded the bank, and one of its buildings survived until demolished by a real estate speculator in 2010. (Courtesy of the Denson Archive.)

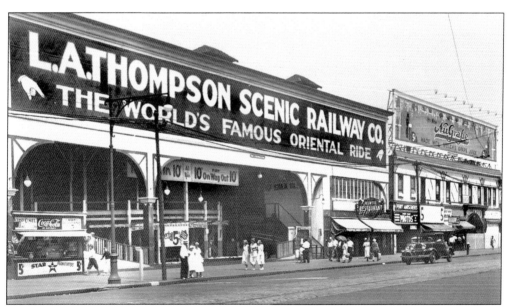

LaMarcus Thompson's Oriental Scenic Railway on Surf Avenue at West Tenth Street had a cavernous entrance. The building would suffer through many renovations and fires before being taken by the city through eminent domain and demolished in 1954 to make way for public housing. (Courtesy of the Coney Island History Project.)

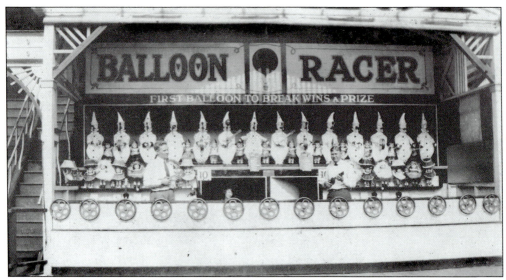

Seasonal amusement concessions and small businesses have been the mainstay of Coney Island since its earliest days. Although some businesses owned property, most leased space on a seasonal basis. This balloon race operated at Luna Park in the 1920s. (Courtesy of the Denson Archive.)

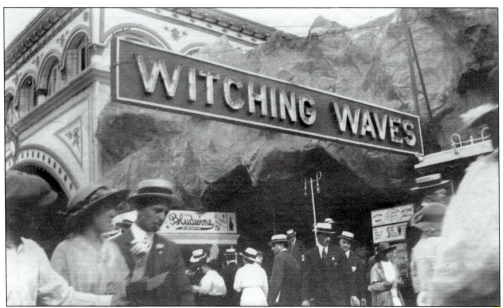

Theophilus Van Kannel's Witching Waves ride debuted at Luna Park in 1907. It had an undulating oval metal track traversed by two-seat scooter cars. Van Kannel also invented the revolving door. (Courtesy of the Denson Archive.)

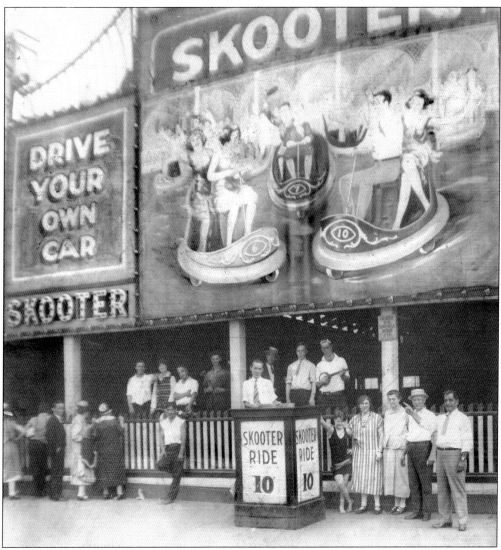

A stylized painted banner hung above one of Coney's largest Skooter rides on Surf Avenue at West Sixth Street. The ride was one of a series of attractions built on the site of Dreamland after it was destroyed by fire. The entire Surf Avenue frontage was reclaimed by the city in 1954 and cleared to make way for the Aquarium. (Courtesy of the Denson Archive.)

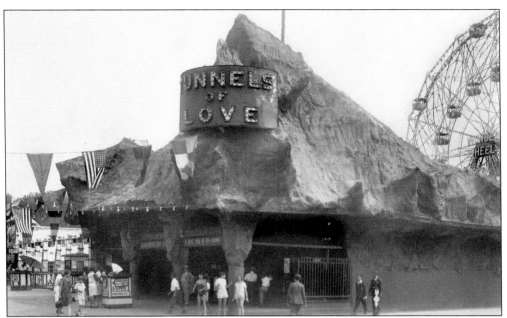

The plural s was added to the Tunnels of Love because "Tunnel of Love" was patented. For some inexplicable reason, the first thing encountered in this dark ride was a scale model of the Vatican. (Courtesy of the Coney Island History Project.)

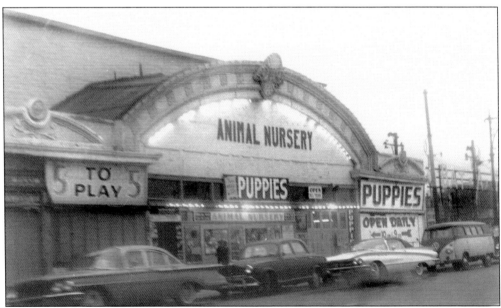

Murray Zaret's Animal Nursery opened in a Surf Avenue building that once served as the entrance to the Ben Hur Race. The Animal Nursery was popular with a generation of schoolchildren who came on class trips to feed the baby animals. Zaret and his pet chimp were regulars on Saturday morning children's television shows. The attraction later moved to a location near West Fifteenth Street when Brightwater Towers was built on this site. (Courtesy of the Denson Archive.)

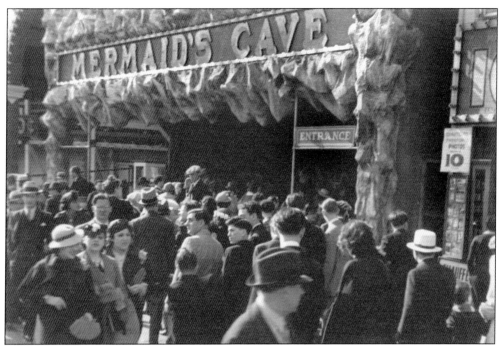

Joe Bonsignore and John D'Ricco created the Mermaid's Cave dark ride in a space below the L.A. Thompson coaster that formerly housed the Curtis Restaurant. (Courtesy of the Denson Archive.)

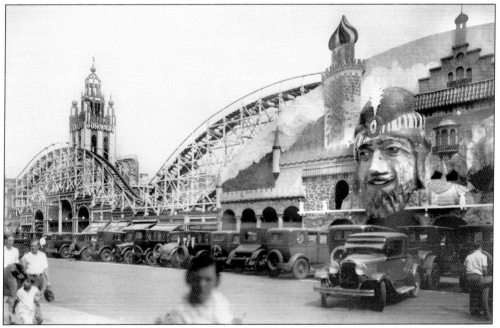

A grinning face adorned the Harem dark ride inside the Tornado roller coaster's amusement bazaar on Stillwell Avenue. The Tornado's magnificent jewel-encrusted tower can be seen at left. Dozens of businesses, including bathhouses, arcades, fortune-tellers, shooting galleries, and restaurants, were located beneath the coaster. (Courtesy of the Coney Island History Project.)

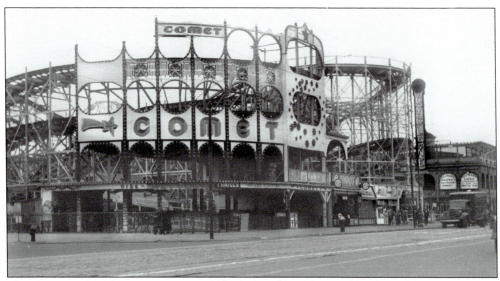

The Comet and Cyclone coasters operated side-by-side until McCullough's Kiddie Park took the Comet's place in 1945. The Comet opened in 1921 and went through a series of name changes that included the Big Dipper and the Wildcat. (Courtesy of the Denson Archive.)

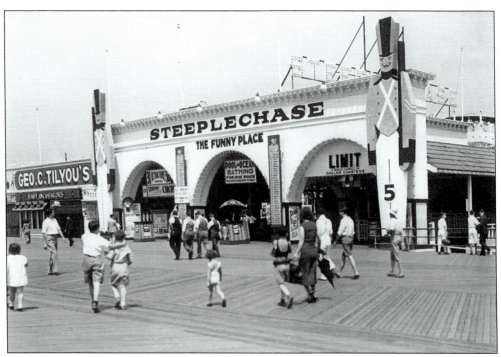

Giant wooden soldiers and Dr. Couney's baby incubator exhibit flanked Steeplechase Park's Boardwalk entrance before a fire destroyed the entrance and adjoining Flying Turns coaster in 1939. The Parachute Jump was installed at this location in 1941. (Courtesy of the Coney Island History Project.)

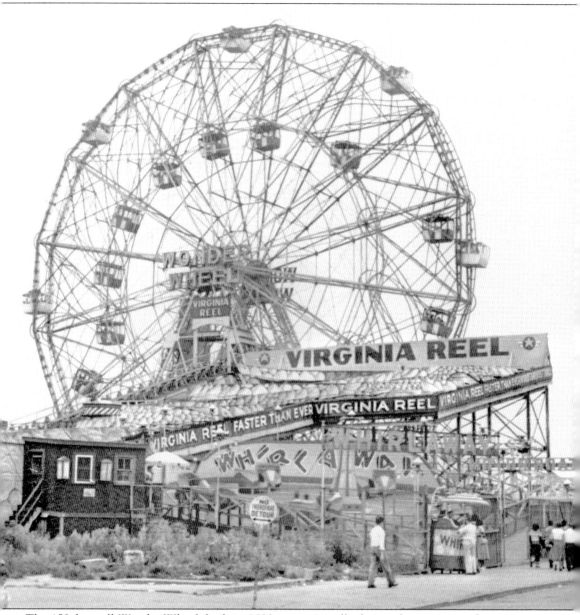

The 150-foot-tall Wonder Wheel, built in 1920, was originally designed as a perpetual motion machine. The wheel has 16 swinging cars and 8 stationary cars and weighs 400,000 pounds. It is Coney Island's oldest ride and the centerpiece of Deno's Wonder Wheel Park. (Courtesy of the Coney Island History Project.)

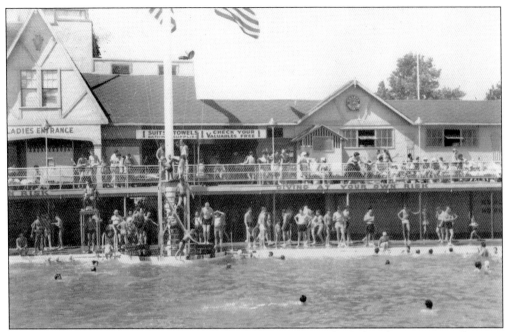

Washington Baths' Olympic-size saltwater pool had a frightening high dive that was a rite of passage for generations of children. The bathhouse resort, located at West Twenty-first Street between Surf Avenue and the Boardwalk, was founded and operated for 60 years by Harry Smolensky. (Courtesy of the Coney Island History Project.)

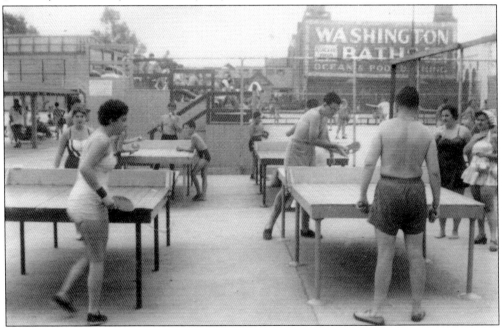

Washington Baths offered many attractions and activities, including steamrooms, saunas, ping-pong, handball, boxing, and weightlifting. At one time, there were dozens of bathhouses and swimming pools along Coney Island's Boardwalk. Stauch's Baths, managed by Ruby and Phil Jacobs, operated until the early 1970s. (Courtesy of the Coney Island History Project.)

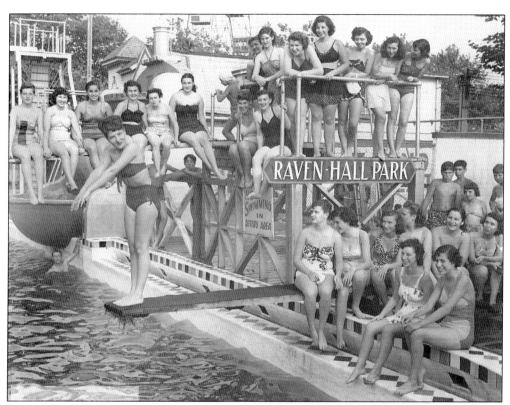

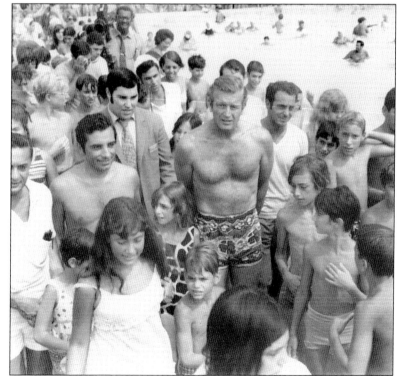

Peter Ravenhall arrived on Coney Island in 1863, opened a hotel, and then expanded his business into Coney's largest resort. Ravenhall Park was destroyed in a devastating fire in 1963. (Courtesy of the Coney Island History Project.)

Mayor John V. Lindsay showed off his physique beside the pool at Brighton Beach Baths in the 1960s. (Courtesy of the Coney Island History Project.)

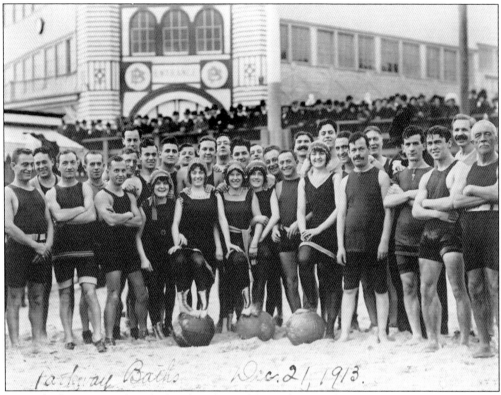

Winter bathers exercised on the beach in front of the Parkway Baths in 1913. Once an organization with a handful of elderly but experienced swimmers, the Coney Island Polar Bear Club has gained a younger membership and still holds regular winter swims every Sunday. The annual New Year's Day swim has grown into a major event attended by thousands of participants and observers. (Courtesy of the Denson Archive.)

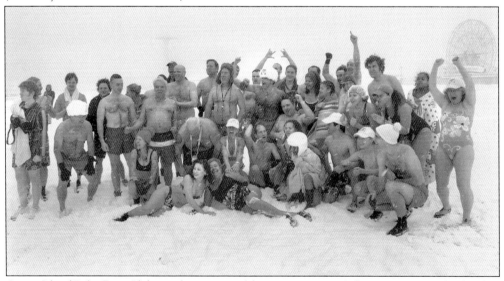

Coney Island Polar Bear Club members prepared for an icy swim on February 12, 2006, the day that 26.9 inches of snow fell on New York, breaking all records. (Photograph by Charles Denson.)

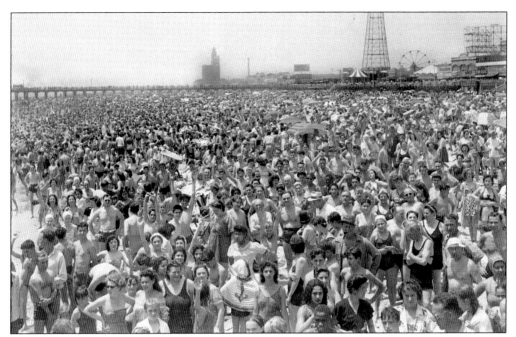
This was a typical summer Coney Island beach crowd in 1945. (Courtesy of the Coney Island History Project.)

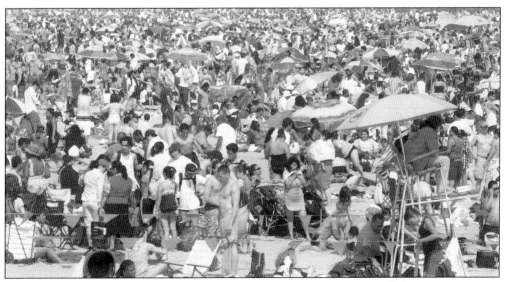
Coney Island's beach was filled to capacity on July 4, 2010. Weather is still the most important factor in Coney Island's short amusement season. (Photograph by Charles Denson.)

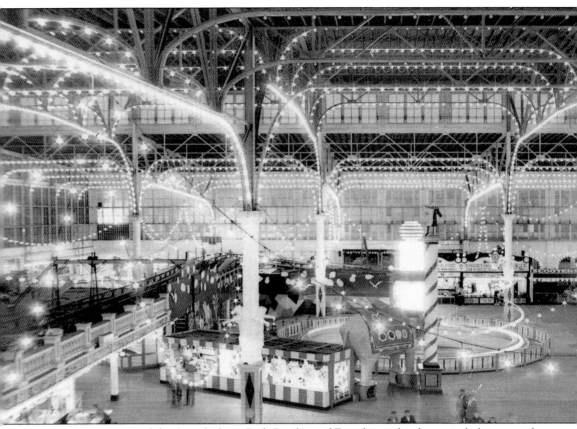

An interior view of the Steeplechase Park Pavilion of Fun shows the dramatic lighting on the structure's steel trusses. The El Dorado carousel is spinning at right, and the loading platform for the Steeplechase horse race is at left. Numerous games, food stands, and concessions are spread across the pavilion's wooden floor. George C. Tilyou built the massive pavilion in 1908 after a fire

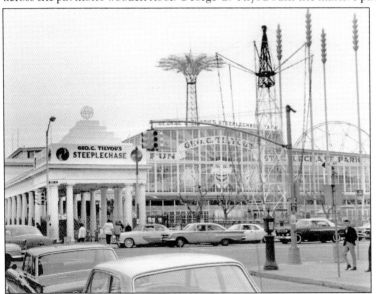

The Steeplechase Park Pavilion of Fun is shown in the early 1960s, shortly before it was torn down. The park's ticket booths, turnstiles, and Caterpillar ride were bought by Astroland. (Photograph by Abe Feinstein.)

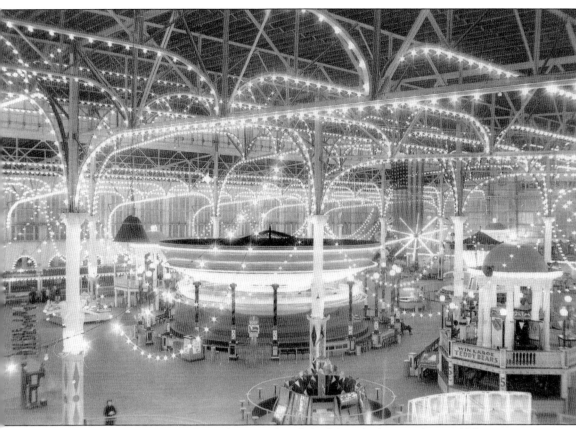

the previous year leveled his park. Fred Trump demolished Steeplechase Park in 1966, hoping to have the location rezoned for a housing project. A minor-league ballpark now occupies half the site. The other half was rezoned for high-rise residential development in 2009 by the Bloomberg administration. (Courtesy of the Astroland Archive.)

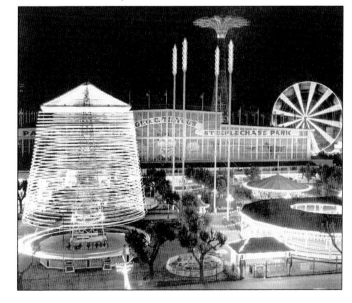

Steeplechase Park was an impressive sight at night. Tilyou's Ferris wheel, his first attraction, is at right. The tall wheat stalks at center were brought from the 1939–1940 New York World's Fair. (Courtesy of the Coney Island History Project.)

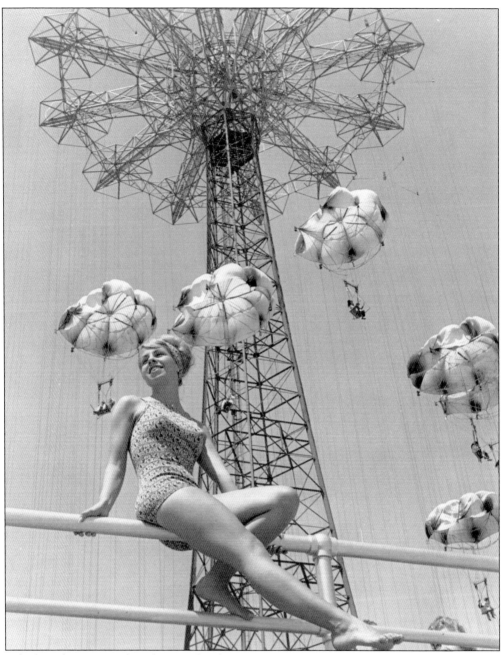

A bathing beauty posed on the Boardwalk in front of the Parachute Jump as riders glided to the ground behind her. The Parachute Jump last operated in 1964. The ride was slated for demolition but was saved and given landmark status. (Courtesy of the Denson Archive.)

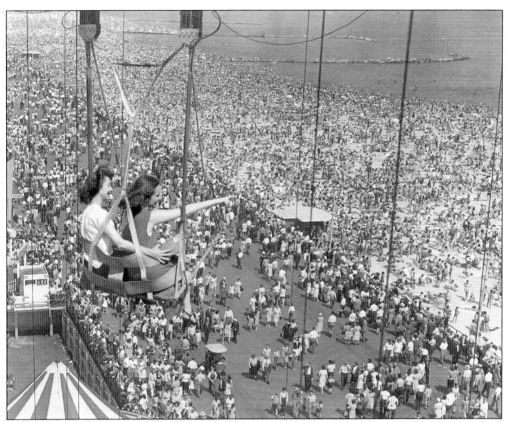

Two riders took in the view as they ascended to the top of the Parachute Jump. The ride's seating was primitive compared with the restraints required on modern attractions. (Courtesy of the Coney Island History Project.)

The Boardwalk entrance to Steeplechase had a hidden blower that raised skirts. (Courtesy of the Denson Archive.)

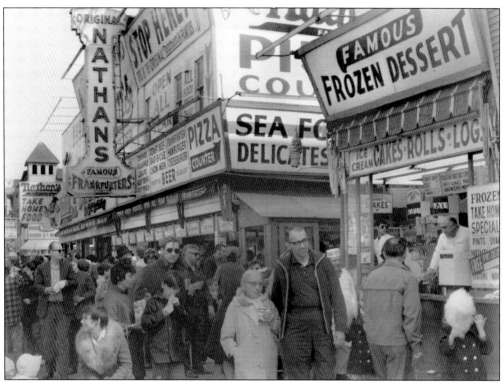

Nathan's Famous, Coney Island's most famous "grab joint," still operates at its original location on Surf Avenue. The Handwerker family sold the franchise in 1987. (Courtesy of the Coney Island History Project.)

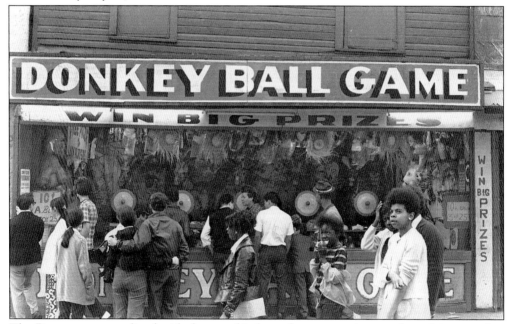

The Bowery was once lined with dozens of independent concessions, such as this game that operated in the 1970s. (Photograph by Charles Denson.)

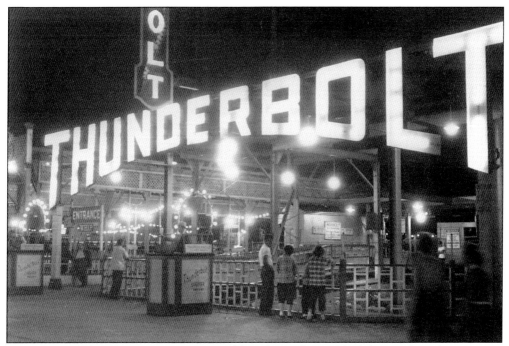

The Thunderbolt roller coaster was designed by John Miller and built by Frank Darling in 1925. Located under the boldly lit Bowery entrance and beside the loading platform was a lovely rose garden, adding to the coaster's homey feel. It last operated in 1982. (Courtesy of the Denson Archive.)

Mae Timpano continued to live in the home below the Thunderbolt after the death of her boyfriend, owner Fred Moran. The coaster was ordered demolished by Mayor Rudolph Giuliani in November 2000. The new owner, Horace Bullard, won a lawsuit over the demolition but was awarded only $1 in damages for the loss of the historic John Miller–designed coaster. (Photograph by Charles Denson.)

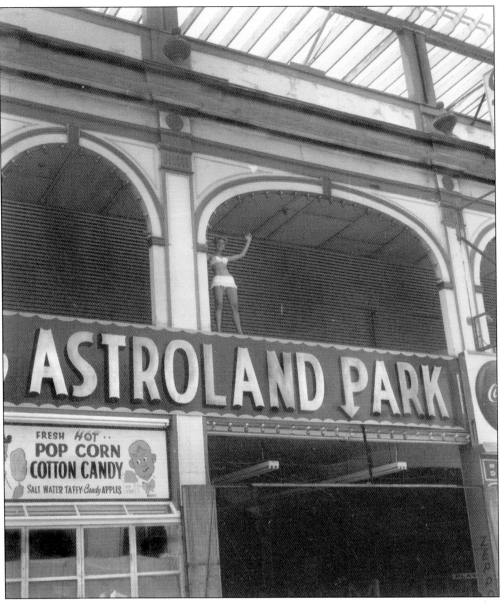

The first name chosen for the new amusement park was Feltmans Astropark. It was later changed to Astroland. Here, a greeter welcomes visitors to Astroland from a perch above Feltmans Restaurant in 1963. The old Surf Avenue restaurant was preserved and went through various incarnations as Buddee's Bar, Charcoal Dan's, the Roaring 20s, and, finally, Astroland Restaurant. The building burned to the ground in 1975. (Courtesy of the Astroland Archive.)

Two

Feltmans and Wonderland

Coney Island has played numerous roles. The one that has endured is its reputation as the "Poor Man's Paradise" or "People's Playground." To New York's burgeoning immigrant population, a visit to Coney Island represented a freedom they had never experienced, an easy escape from stifling tenements and sweatshops, and a way to assimilate by shedding the cultural restraints of the old country. For those with imagination, it was the place to realize unusual dreams or start a family business. Coney became the world's most famous resort and the frequent target of speculators, reformers, zealots, and corrupt politicians, who saw it as a place that needed control. Coney Island never had a master plan, but there was no shortage of government officials and city planners who would try to shape it.

German immigrant Charles Feltman started small and navigated the dangerous political climate of the 1870s at a time when corrupt political boss John Y. McKane was illegally dividing up and selling off Coney Island. Feltman wound up with a prime three-acre parcel at the center of the island. He also outlasted McKane, who was sentenced to prison for his crimes. Feltman began building an establishment that by the early 1900s covered a full city block with various attractions: nine restaurants, a roller coaster, a carousel, a ballroom, an outdoor movie theater, a hotel, a beer garden, a bathhouse, numerous themed bars, a beach pavilion, a maple garden dining concourse staffed by singing waiters, and a full-scale re-creation of a Tyrolean village. Feltman's shore dinner was a favorite of the financier Diamond Jim Brady as well as Pres. William Howard Taft. The resort was at its peak when Feltman died in 1910, but his restaurant and its 10¢ hot dogs did not survive Coney's transformation into the Nickel Empire.

When Dewey Albert and Nathan Handwerker bought the property in 1954, it consisted of dilapidated structures and an odd assortment of 30 attractions and concessions. A crumbling two-story wooden arcade ran the length of West Tenth Street, and a steam train navigated half the property. The partners decided to upgrade the grounds and create a new amusement park called Wonderland.

The properties surrounding Wonderland were in transition, and new housing developments were opening on former amusement sites. Dozens of high-rise towers were being constructed across Surf Avenue, and the adjacent New York Aquarium had opened the year before. Wonderland turned out to be a good location, between the Wonder Wheel and the Cyclone roller coaster, and the park had no shortage of operators willing to lease space in the park. After Handwerker left the partnership, Dewey Albert suddenly found himself deep inside the amusement business as an accidental impresario.

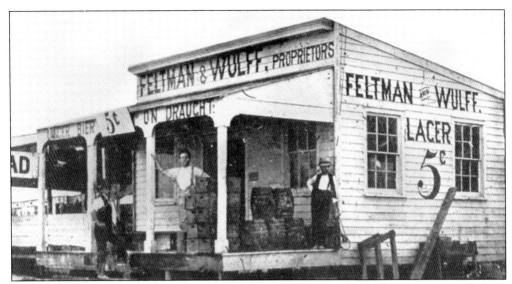
After giving up his traveling pie wagon, Charles Feltman opened a food stand in a small shack set among Coney's sand dunes. (Courtesy of the Coney Island History Project.)

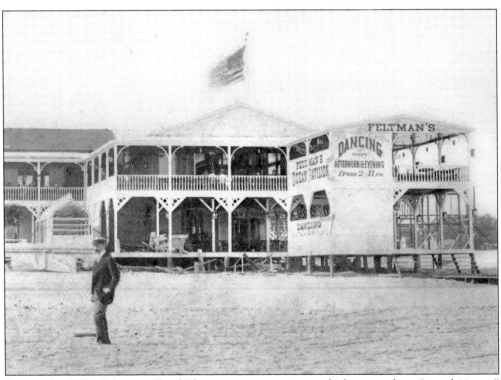
During the 1870s, Feltman offered "dancing every evening and afternoon from 2 until 11 p.m." (Courtesy of the Denson Archive.)

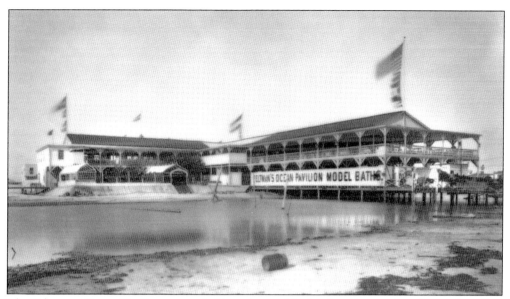

The Feltmans Ocean Pavilion expanded in unison with the shoreline as the adjacent Iron Pier captured sand, enlarging the beach by hundreds of feet. (Courtesy of the Denson Archive.)

An exciting addition to Feltmans Ocean Pavilion was the Ziz roller coaster, a small out-and-back ride that reached a height of 35 feet. The coaster had a musical composition written in its honor: the 1907 "Ziz Two Step March," by Alfred Feltman. (Courtesy of the Denson Archive.)

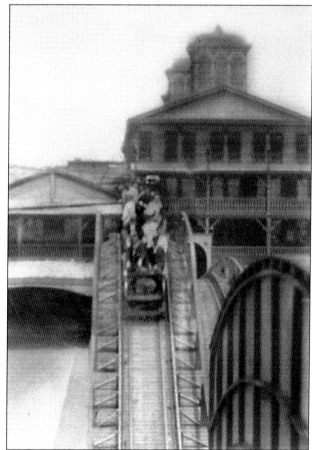

61

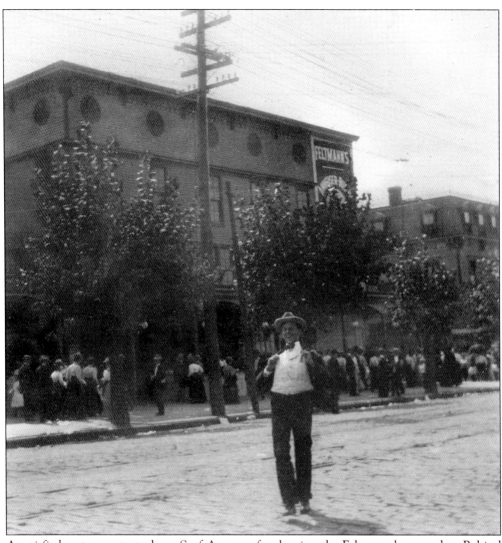

A satisfied customer struts down Surf Avenue after leaving the Feltmans beer garden. Behind him is the three-story Feltmans Restaurant before the addition of wooden arches. The dormer windows of the Grashorn Building can be seen at right. (Courtesy of the Denson Archive.)

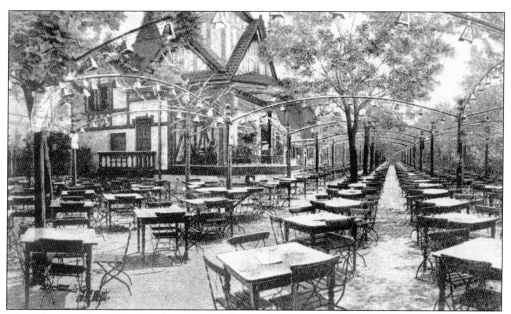
The Feltmans Deutscher Garden offered alfresco dining and entertainment by singing waiters. (Courtesy of the Denson Archive.)

An advertisement for Feltmans showed an assortment of culinary offerings. (Courtesy of the Denson Archive.)

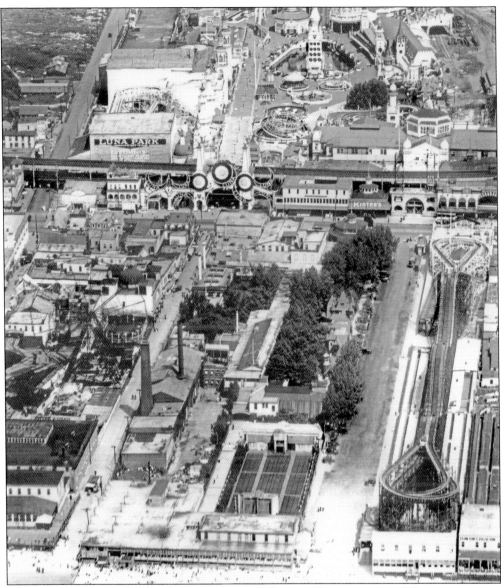

A 1920 aerial image shows the Feltmans property and surrounding attractions. Feltmans, at center, extends from the beach to Surf Avenue. At left is the Wonder Wheel under construction. The large chimney belongs to the Feltmans powerhouse. In the foreground is the outdoor movie theater. The area surrounded by trees is the German village and beer garden. The roller coaster at right is the Giant Racer. At top, across Surf Avenue, is the entrance to Luna Park. At right top is the Sea Beach Palace, shortly before its demolition. (Courtesy of the Denson Archive.)

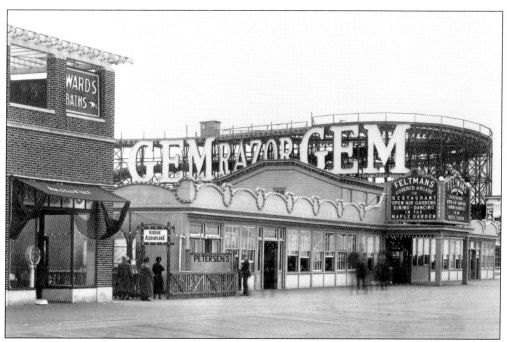

A Feltmans marquee hung above the Boardwalk entrance to the restaurant in 1924. All the shorefront businesses constructed new facades and second-level entrances after the Boardwalk opened in 1923. (Courtesy of the Denson Archive.)

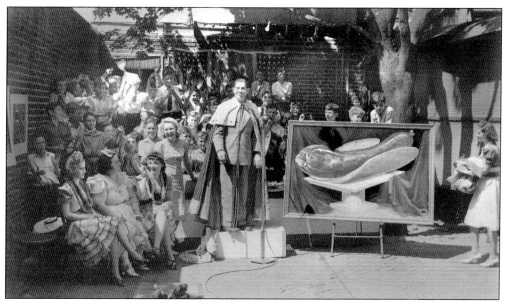

Milton Berle judged an art contest at Feltmans during National Hot Dog Day in 1939. He announced that the event's slogan would be "E Pluribus Hot Dog." (Courtesy of the Coney Island History Project.)

MAJOR RENOVATION PROGRAM AT
FELTMAN'S
CONEY ISLAND, NEW YORK
OFFERS BIG OPPORTUNITY FOR RIDES AND CONCESSIONS

WANT — WANT — WANT

MAJOR RIDES
(New Model and European)

KIDDIE RIDES
(Must be in excellent shape)

ARCADE
and some concessions

ATTRACTIVE TERMS & LEASES

Located in the heart of an area visited by 60 million people annually

Write—Wire—Call

H. RAPPS
185 Montague St., Brooklyn 1, N. Y.
TRiangle 5-4390

A 1961 advertisement run by Herman Rapps, Dewey Albert's partner, sought rides for the park. (Courtesy of the Astroland Archive.)

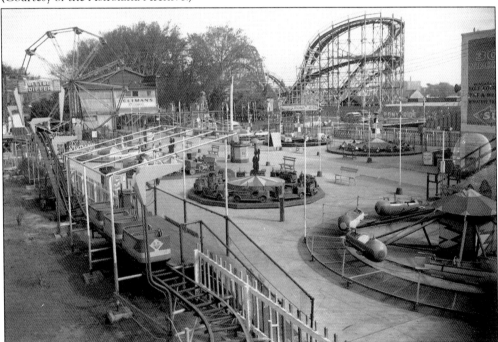

Among Wonderland's kiddie-park attractions were the Little Dipper coaster, Mangels fire engines, and the pony ride featured in the 1953 movie *The Little Fugitive*. (Courtesy of the Astroland Archive.)

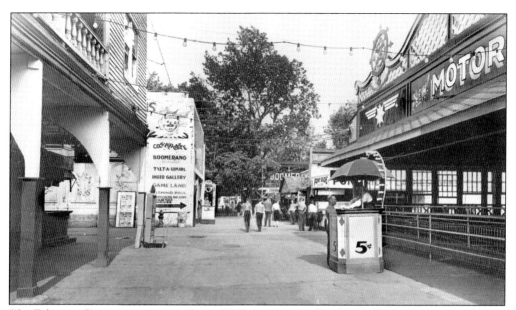

The Feltmans Bowery entrance at Jones Walk was eventually closed off after a property dispute with an adjacent landowner. Feltmans attractions included the Cock-eyed Castle dark ride, the Boomerang, the Tilt-a-Whirl, "olde-time movies," and a fishing pond. (Courtesy of the Coney Island History Project.)

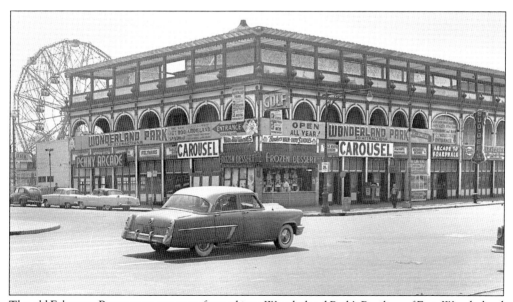

The old Feltmans Restaurant was transformed into Wonderland Park's Pavilion of Fun. Wonderland offered 30 attractions and Coney's largest kiddie park. When Dreamland Park was proposed in 1910, it was also called Wonderland, and early renderings and postcards showed the Wonderland name above the entrance. (Courtesy of the Astroland Archive.)

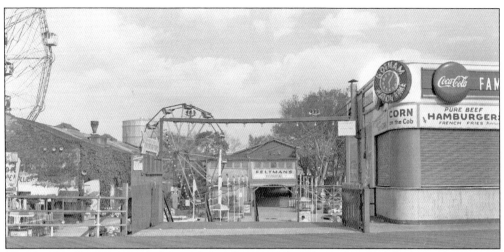

The Boardwalk entrance to Feltmans led to the original 1876 arcade, which had once been at the ocean's edge before the beach was expanded. The snack bar at right would later house Gregory and Paul's Restaurant. (Courtesy of the Astroland Archive.)

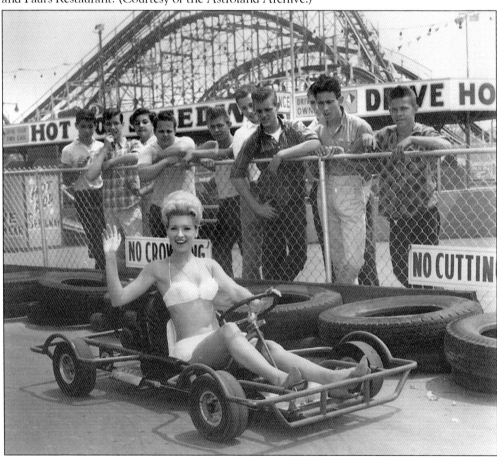

A crowd of young men admires the driving skills of a swimsuit-clad model at Wonderland. (Courtesy of the Astroland Archive.)

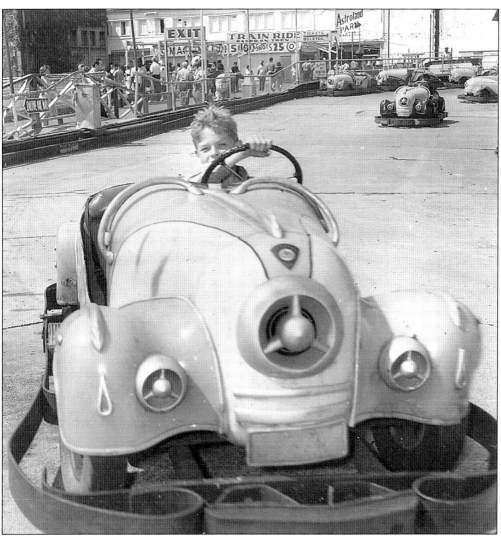
German-made, gas-powered hot rods were among the popular attractions during Astroland's early incarnation. (Courtesy of the Astroland Archive.)

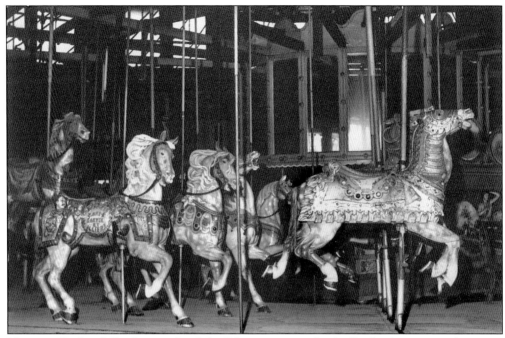

Historian Frederick Friede considered the Feltmans carousel to be "by far the greatest American carousel." It included some of the best work of carvers Marcus Illions and Charles Loof as well as a Bruder Elite Apollo band organ. (Courtesy of the Astroland Archive.)

Some of the finest examples of the bejeweled Coney Island style of carving could be found among the 76 wooden horses, two chariots, and one giraffe that made up the Feltmans carousel. The Wonderland partners kept it operating for a decade until it became too expensive to maintain. The carousel was finally sold in 1964 and combined with parts of the Stubmann carousel before reopening at the 1964–1965 New York World's Fair. (Courtesy of the Astroland Archive.)

This 1870s arcade led from Wonderland's Surf Avenue entrance to the Boardwalk before it was condemned and demolished in 1962. (Courtesy of the Astroland Archive.)

Wonderland's miniature golf course was operated by Jack Merr. (Courtesy of the Astroland Archive.)

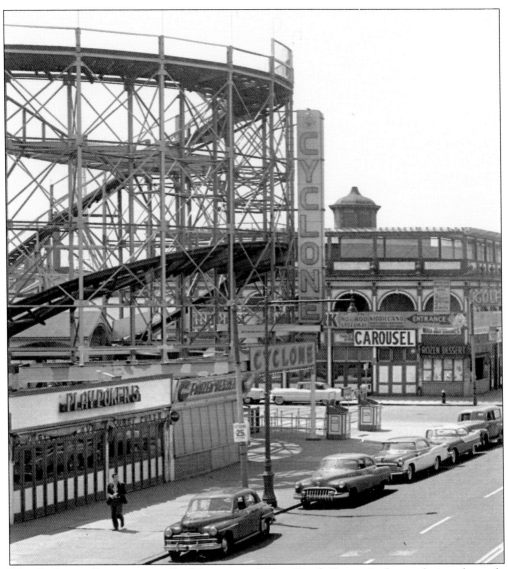

The Cyclone roller coaster, at Surf Avenue and West Tenth Street, is shown during the early 1950s before the maze was added at the entrance. A small cupola above the Feltmans building provided illumination for the Feltmans Superba Carousel below. The poker game arcade at left was part of the McCullough amusement park that replaced the Comet roller coaster. The small frozen dessert stand below the Cyclone housed a series of souvenir stores, food stands, and arcade games before doing service as the exhibit center for the Coney Island History Project. (Courtesy of the Astroland Archive.)

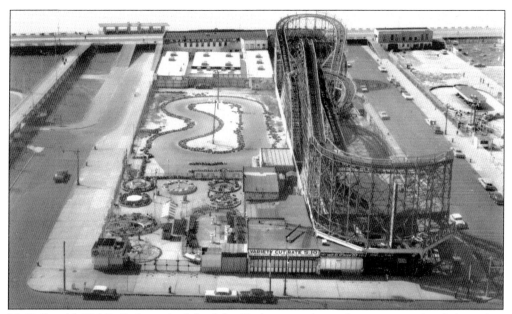

McCullough's Kiddie Park, to the left of the Cyclone, was located on property that belonged to the Tilyous before the family sold it to the city for an Aquarium parking lot. (Courtesy of the Astroland Archive.)

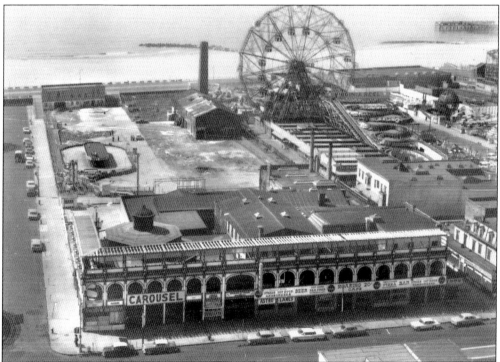

In 1962, the first phase of the Feltmans demolition was complete. Later that year, the old brick powerhouse would be leveled and new generators installed. Feltmans and Astroland always generated their own electricity, avoiding the undependable Coney Island power grid. (Courtesy of the Astroland Archive.)

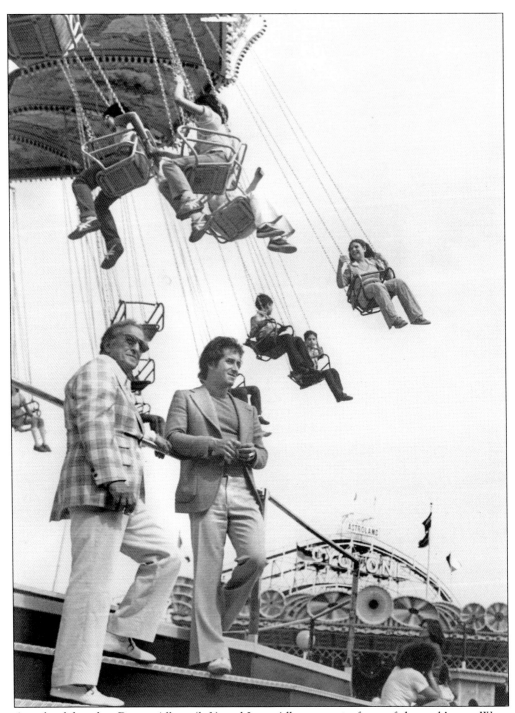
Astroland founders Dewey Albert (left) and Jerry Albert pose in front of the park's new Wave Swinger in 1976, the year they spent more than $2 million on park improvements. (Courtesy of the Astroland Archive.)

Three

BUILDING ASTROLAND

It was the height of the Cold War and the beginning of the space race, an optimistic era when rockets, technology, and astronauts were all the rage. Coney Island was in a slump and had not had any new major rides since the end of World War II. The great Victorian Steeplechase Park, still in operation a few blocks away, featured attractions that were antiquated but beloved relics of another era. Coney Island needed a futuristic boost that would bring it into modern times. In May 1961, Pres. John F. Kennedy announced the Apollo program with the goal of landing men on the moon. That same year, Dewey and Jerry Albert announced a goal of their own: to transform Feltmans Wonderland Park into a space-age theme park called Astroland.

Construction of the park began in late 1962 with the demolition of the condemned structures on the Feltmans property, and an interim park opened for the season. Cranes and bulldozers worked around the clock at the site throughout the winter and spring of 1963, and by summer, Phase 1 of the park opened to the public. Featured attractions included the Indianapolis Speedway Go-Kart Track, Moon Rocket, Space Orbit ride, Satellite Jet, Calypso, and Himalaya, along with an assortment of kiddie rides. The only piece still missing was a tower.

Every Coney Island amusement park had featured a tower as its centerpiece. Steeplechase had the spidery steel Parachute Jump; Luna had the sparkling Kaleidoscope Tower; Dreamland had the magnificent Beacon Tower. The Alberts' park would have an Astrotower. The Astrotower needed to be the tallest attraction in Coney Island, taller than the Parachute Jump—and at 272 feet, it was. The tower was minimalist and devoid of ornamentation. It was not much to look at during the day but spectacular and glittering when illuminated at night. The cylindrical steel tower was surrounded by a two-level circular observation car that rose to the top while slowly spinning, providing a 360-degree view of the New York area. The three-and-a-half-minute ride was not a thrill ride; it was gentle. The press nicknamed it the "Bagel in the Sky" or "Flying Bagel." Jerry Albert embraced the name, serving bagels and lox at the tower's opening, as his mother cracked a bottle of champagne on its base. When the tower opened in July 1964, the conversion of Feltmans into Astroland was complete.

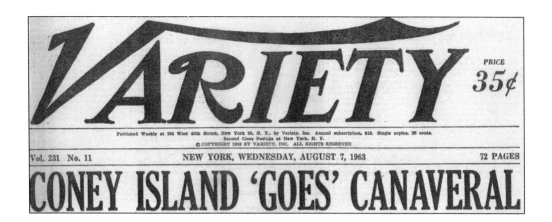

The media always engaged in hyperbole when covering Astroland. (Courtesy of the Astroland Archive.)

ASTRO, LUNAR VS. HOT DOGS

By JO RANSON

Brooklyn, Aug. 6.
Coney Island, this season, appears to be in a vortex of supersonic space-spinning and stomach-detonating speed. This is the year that a number of new faces have pacted deals with several of Coney's canny showmen to turn the seaside amusement zone into a gill-sized "go" version of Cape Canaveral.

Nowhere is this fierce concern with rocket propulsion, satellite launchings and lunar landings more evident than at the new Astroland on the old Feltman property.

Outdoor show biz savants are predicting that the new facelifted Coney Island, after breaking in its new batch of 1963 attractions, will be about ready for the big push in 1964, the year it figures on getting the spillover swarms from the World's Fair at Flushing Meadows.

Thursday, September 12, 1963

THE Hollywood REPORTER

Stars Attending Coney Film Fest

New York. — Jay Ward's Coney Island Film Festival, kicking off his "Fractured Flickers" teleseries today, will be attended by numerous stars and celebrities. Sybil Burton, Sam Levenson, Jean Pierre Aumont, Tom Poston, Hermione Gingold, Marty Ingels, Julie Stein, Mike Nichols, Robert Redford and Maureen O'Sullivan are among those who have accepted. Ward anticipates more than 3000 people will attend the festival, which will take over the entire Astroland Amusement Park and will feature a screening of eight segments of "Fractured Flickers."

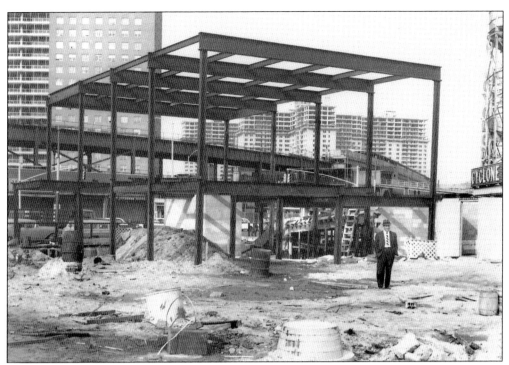
Dewey Albert stands in front of the steel skeleton of the Surf Avenue Skyride terminal. Construction of the park began in the winter of 1962. When the Skyride closed a decade later, the terminal was renovated and transformed into the Astroland offices. (Courtesy of the Astroland Archive.)

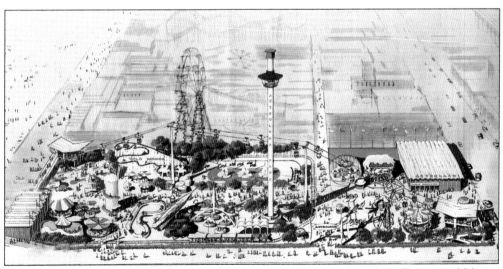
An early rendering of the new park highlights the attractions that the Alberts would bring to Coney Island. All the rides were up and running by the 1964 season. (Courtesy of the Astroland Archive.)

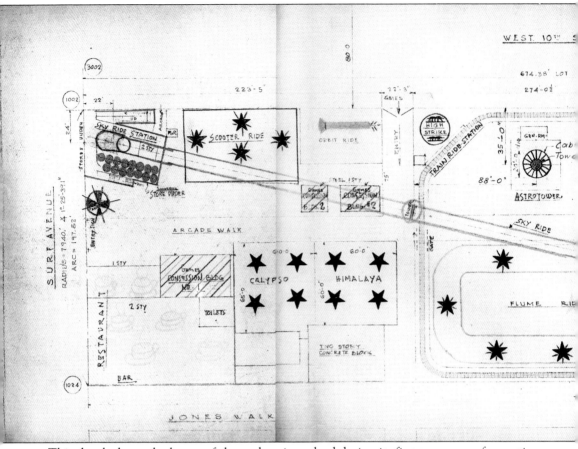

This sketch shows the layout of the park as it evolved during its first two years of operation.

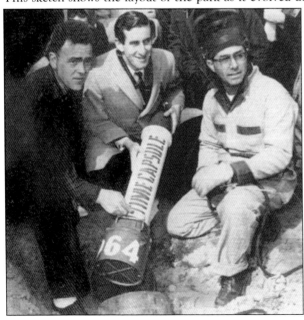

From left to right, Astrotower manager Charley Bower, Jerry Albert, and welder Joe Peluso slide the Astrocule time capsule into the tower foundation. (Courtesy of the Astroland Archive.)

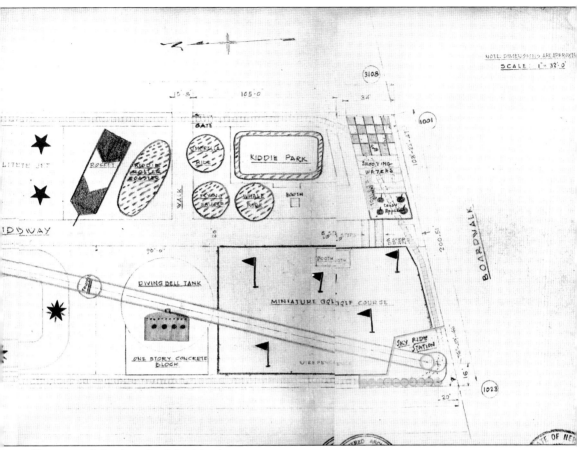

(Courtesy of the Astroland Archive.)

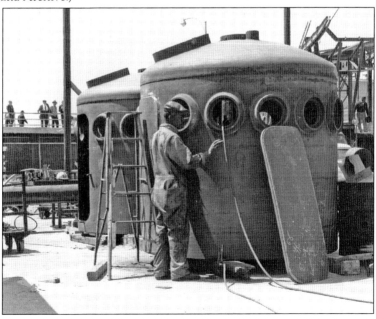

A welder outfits the park's diving bells before installation. The design was based on the bathysphere, a solid, steel, deep-sea submersible created in the 1930s for lowering by cable to the seafloor to conduct scientific research. (Courtesy of the Astroland Archive.)

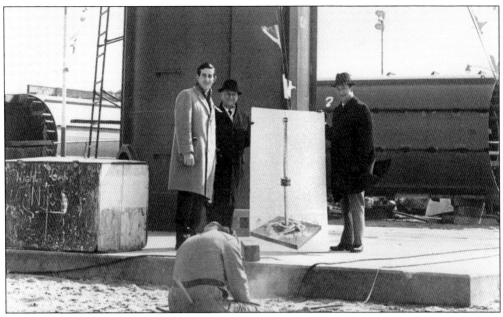
Jerry Albert (at left) displays a rendering of the Astrotower as the Astroland time capsule is prepared for placement in the park's 1964 dedication. (Courtesy of the Astroland Archive.)

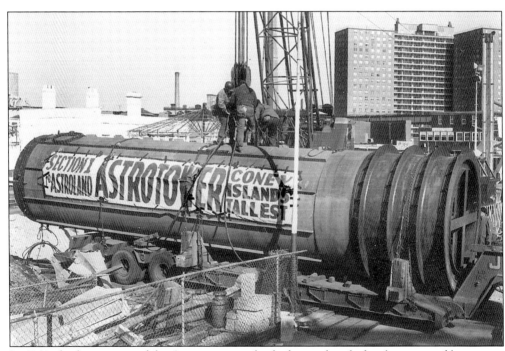
In 1964, the first section of the Astrotower was backed into place before being raised by a crane and embedded in a massive concrete foundation. (Courtesy of the Astroland Archive.)

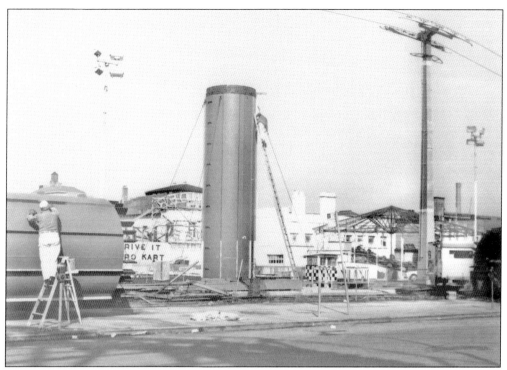
The Astrotower's base stands in place as another section is prepared for installation. (Courtesy of the Astroland Archive.)

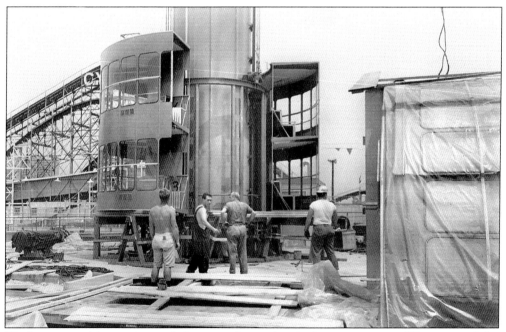
Workers assemble sections of the tower's two-level observation car. (Courtesy of the Astroland Archive.)

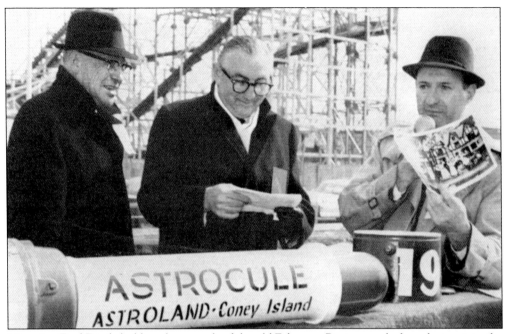

Historian Fred Friede holds a photograph of the old Feltmans Restaurant before placing it in the Astrocule time capsule. (Courtesy of the Astroland Archive.)

24-Brooklyn—New York Journal-American, Sun., March 8, 1964
Coney Astrotower: Seen for 37 Miles

The exact spot where President Taft and his party picnicked and where Diamond Jim Brady ate his thick steaks was the site for the planting of a time capsule yesterday at the groundbreaking ceremony for the Astrotower.

A renaissance of Coney Island is taking place upon the site once known as Feltman's, the famed Coney Island beer garden, now an $8-million modern amusement park called Astroland, the first new amusement area since 1921. Over the time capsule will rise Coney Island's tallest structure, the Astrotower, a $1,672,-000 combination observation tower and thrill ride.

The Astrotower, the only one of its kind in the world, should be completed by April 30. It will rise to 303 feet and will be seen for 37 miles. The Astrotower will be 62 feet higher than the Parachute Jump, just five blocks east.

The observation car, in the form of a huge two-story round plastic cabin will hold 60 passengers, using the tower as a track as it spirals up to the 303 feet height and descends. The tower will have a beacon at its top and will be the first sight of America for incoming vessels.

Into the time capsule will go historic records and photos of old Coney Island as well as a hot dog complete with mustard and many surprise items.

Bunting, flags, a German band playing old beer garden tunes and Coney Island Polar Bears will add to the sound and color of the occasion.

One of the local papers covered the planting of the time capsule. (Courtesy of the Astroland Archive.)

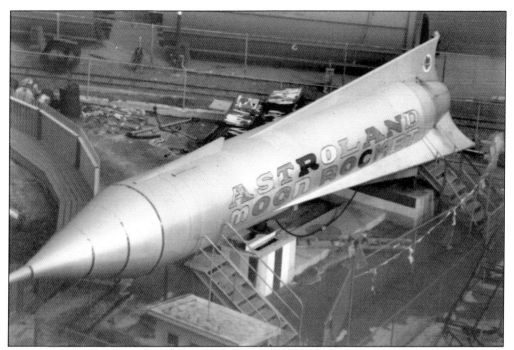

The Astroland Moon Rocket sat surrounded by construction debris as the park took shape. (Courtesy of the Astroland Archive.)

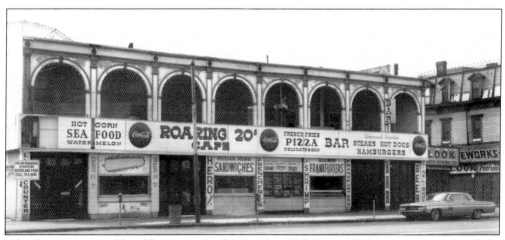

After being cut in half and losing its third story, the old Feltmans Restaurant was renamed the Roaring 20s Cafe. The original photograph murals of old Coney Island remained intact behind the bar until the restaurant burned to the ground in 1975. (Courtesy of the Astroland Archive.)

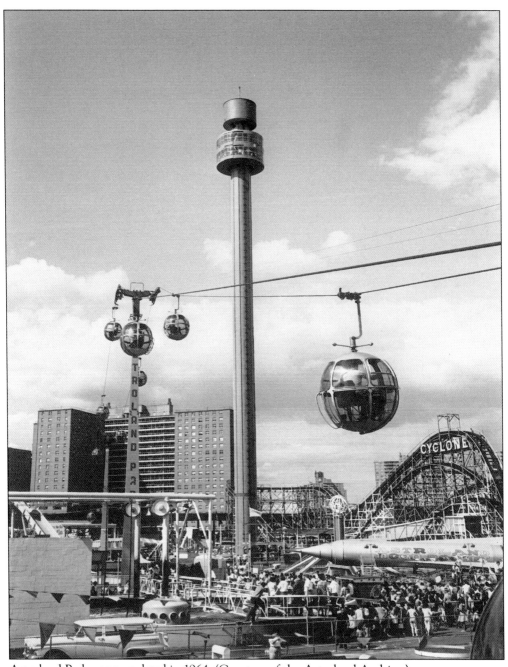
Astroland Park was completed in 1964. (Courtesy of the Astroland Archive.)

Four
Astroland's Journey to the 21st Century

In 1962, Dewey and Jerry Albert's project had no shortage of media coverage. Jo Ranson, writing in *Variety*, described the pair as "canny showmen" who were turning the seaside amusement zone into a "go version of Cape Canaveral!" Astroland's optimistic theme was "Journey to the 21st Century," and the new park was breathlessly described in the press as a "galactic face-lift for Coney Island." The media played up the competition between "old" Steeplechase and "new" Astroland, not realizing that Steeplechase would close forever after the 1964 season.

The Astrotower was a gift to headline writers. An editorial in the *World Telegram and Sun* ran the headline, "Who Wants an Outlandish Astrotower? Who Wants A Big Bagel in the Sky?" Then the paper answered the questions: "There's only one place where anyone would dare to put up such a thing, and that's Coney Island, that land of the frivolous, where gaiety and fun have reigned for years. We're glad to see the old place hasn't lost its zest for the bizarre."

Astroland's attractions were varied. The first year saw a film festival; a Murray the K Rock 'n' Roll Show; the arrival of Coney's first dolphin show, Flipper and Flapper; a dancing waters show on the Boardwalk; and the planting of a time capsule, sealed into the foundation of the Astrotower. Inside the capsule were historic Coney Island photographs and records, Diamond Jim Brady's little black book, a Nathan's hot dog, and a Beatles wig. Astroland, in its first season, was a curious mélange of standard and one-of-a-kind attractions: spaceships next to miniature golf, diving bells next to a steam train. It was an urban park with an open-gate policy. The park provided 300 seasonal jobs for the community.

During its 43-year history, Astroland sponsored air shows by the Thunderbirds, Golden Knights, and Blue Angels, as well as charity events like the Community Mayor's Day for handicapped children. The park survived and quickly recovered from a dramatic 1975 fire that destroyed the last remaining portion of the Surf Avenue Feltmans Restaurant. Over the next four decades, the iconic Diving Bells and Skyride were replaced by a succession of new and exciting rides, including the Pirate Ship, Enterprise, Power Surge, Break Dance, Dante's Inferno, Teacups, and Topspin. Despite new technology, the Water Flume and its drenching ride remained the park's most popular attraction and biggest moneymaker. An efficient German mechanic named Horst Kant managed Astroland for three decades until Mark Blumenthal, who also operated Astroland's three game arcades, became the park's last manager. At the turn of the 21st century, Astroland was thriving and ready for its next act when politics and ill-defined urban planning stepped into the picture to radically alter Coney Island's landscape.

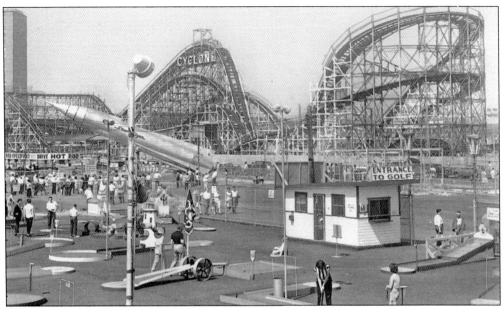

In 1963, Astroland Park still had some of Wonderland's attractions, including the hot rods and trout pond. (Courtesy of the Astroland Archive.)

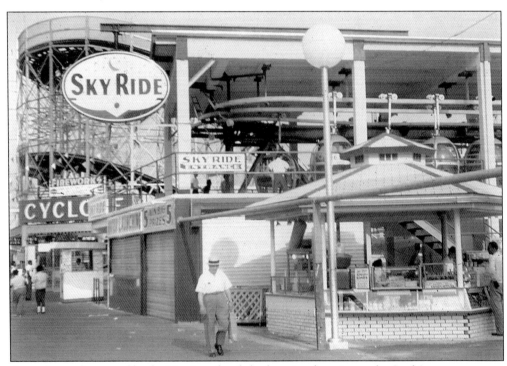

A candy stand operated by the Harrison family had a prime location at the Surf Avenue entrance to the park below the Skyride. (Courtesy of the Astroland Archive.)

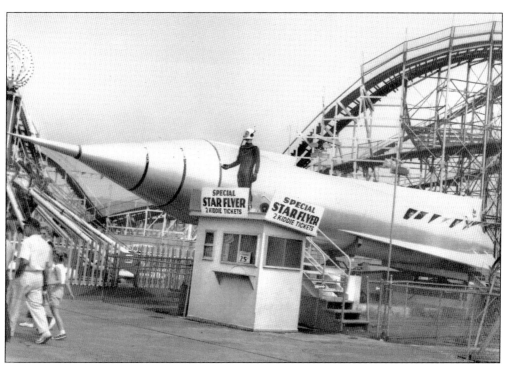

An astronaut perched above the ticket booth beckons riders to the Star Flyer flight simulator. (Courtesy of the Astroland Archive.)

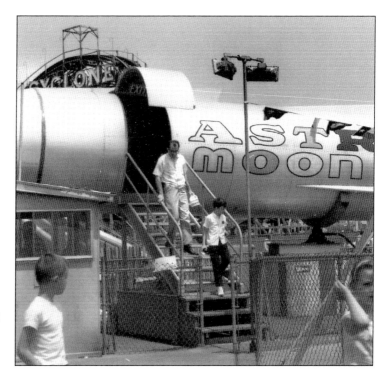

Passengers emerge from an adventure aboard the rechristened Astroland Moon Rocket. (Courtesy of the Astroland Archive.)

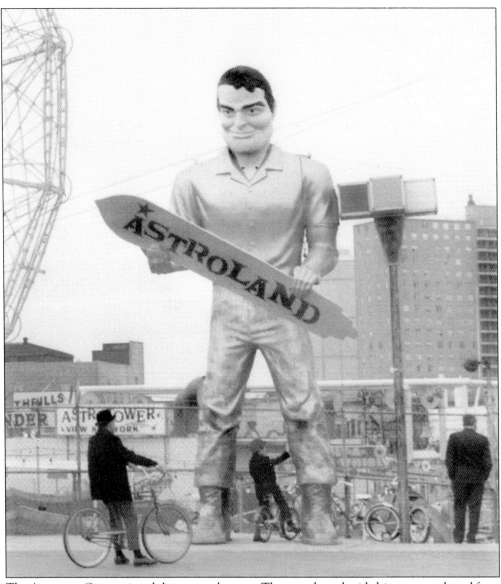

The Astroman Giant pointed the way to the stars. The streetlamp beside him was purchased from the 1964–1965 New York World's Fair. His empty boots remained in place for several years after the giant was removed in the late 1960s. (Courtesy of the Coney Island History Project.)

Astroland's old-fashioned steam train stood out among the park's modern space-themed rides. The tracks looped around the perimeter of the park before entering a tunnel alongside the Boardwalk. The Puglisi Brothers operated the ride during the park's early years. (Courtesy of the Astroland Archive.)

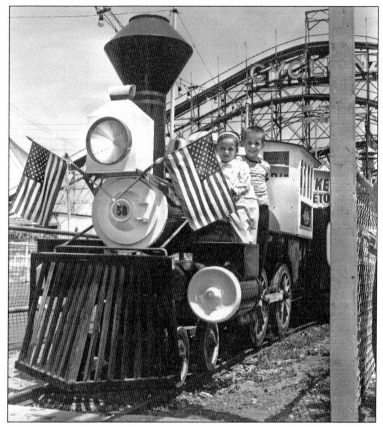

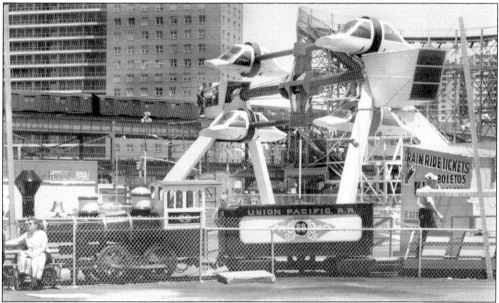

Workers tune up the Space Orbit ride alongside the park's miniature steam train. Coney veteran Wally Roberts operated the troublesome and unpredictable Orbit for a season before selling it. (Courtesy of the Astroland Archive.)

Jackie Goes to Coney

By KENNETH GROSS

Jacqueline Kennedy, who is known to prefer cuisine that is French, last night slipped out to Coney Island for a hot dog. (Is Coney Island *in?*)

It was 9:45 p.m., when Mrs. Kennedy, accompanied by director-actor Mike Nichols, actor Alan Arkin and Arkin's wife, Barbara, drove into an alley behind Nathan's F a m o u s on Surf Av.

Mrs. Kennedy, w e a r i n g a white dress and pink scarf, was immediately recognized. As she and the others ate frankfurters, fried clams, clams on the half-shell and french fried potatoes, a few hundred people gathered on the corner of Stillwell and Surf Avs. to try to see her.

Police of the 60th Precinct received a call for assistance from a patrolman who reported an unruly mob gathered outside Nathan's.

Meanwhile, in the dining room, Mrs. Kennedy wondered why t h e c o f f e e was taking so long. Herbie Harrison, the waiter, was busy on the telephone.

"Guess who I'm waiting on," said Harrison to his wife.

"Get their coffee," ordered Jerry Cohen, the restaurant's general manager.

After he had finished serving, Harrison took off his apron and went home. "I'm too shook up to serve anyone else," he told Cohen.

Mrs. Kennedy told a policeman: "I'd like to go on the boardwalk."

So she and her party were packed in the back of a radio car and whisked to a secluded spot on the boardwalk, far from her fans.

By 11:15, the crowds had given up searching for the famous visitor. Mrs. Kennedy, Nichols and the Arkins made their way back to the restaurant where Cohen had prepared a take-home bag of franks, salami, pickles, clams and relish.

"Maybe," said Cohen, "now they'll stop saying Coney Island is such a bad place."

Arkin and his wife, who used to frequent Coney when they were courting—he proposed to her at a clam bar there—apparently persuaded Mrs. Kennedy to visiting their old stamping ground.

And it may not be her last visit.

Souvenir concessionaire Jerry Epstein, a few booths away from Nathan's, said he had offered Mrs. Kennedy two teddy bears for her children.

She promised to come back for them, Epstein said.

The *New York Post* covered Jacqueline Kennedy's exciting visit to Coney Island in 1966. (Courtesy of the Astroland Archive.)

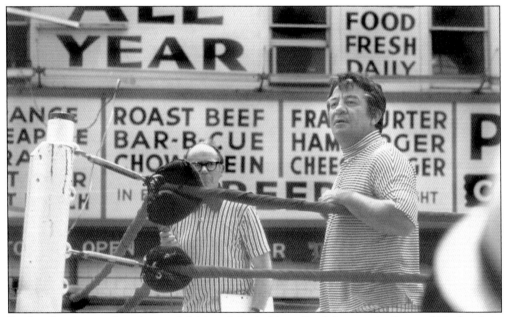

Rocky Graziano refereed an exhibition fight held on Surf Avenue in front of Nathan's in 1970. Muhammad Ali also visited Coney Island for a Boardwalk event that year. (Photograph by Abe Feinstein.)

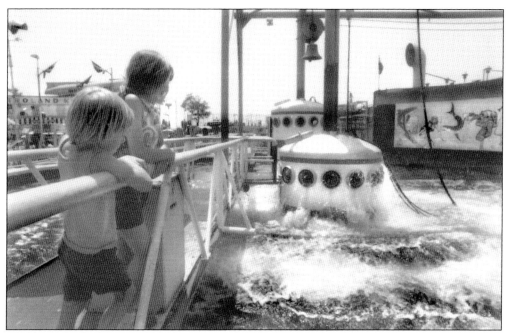

Children watch the Neptune Diving Bells burst to the surface after completing a 30-foot dive into the ride's 50,000-gallon steel tank. Once at the bottom, riders could see outside the bells' portholes treasure-filled chests, divers, live dolphins, and even a sunken car from the Skyride. (Courtesy of the Astroland Archive.)

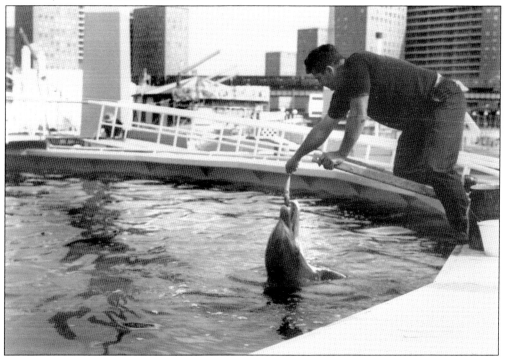

One of Astroland's two performing dolphins receives a treat. Flipper and Flapper were an early attraction at the park but only lasted for one season. (Courtesy of the Astroland Archive.)

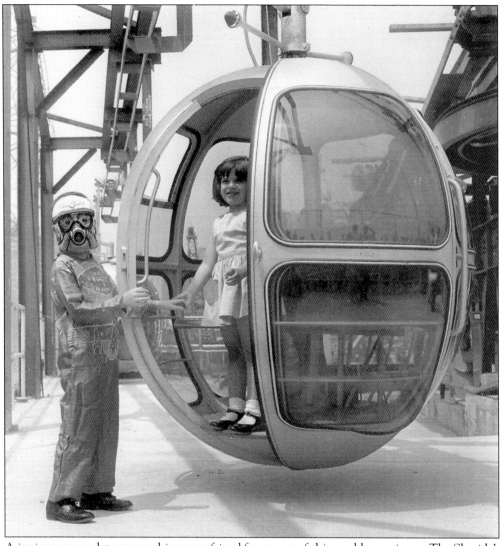

A junior space cadet prepares his young friend for an out-of-this-world experience. The Skyride's 16 full-vision bubble pods traveled 80 feet above the ground from Surf Avenue to the Boardwalk and back. (Courtesy of the Astroland Archive.)

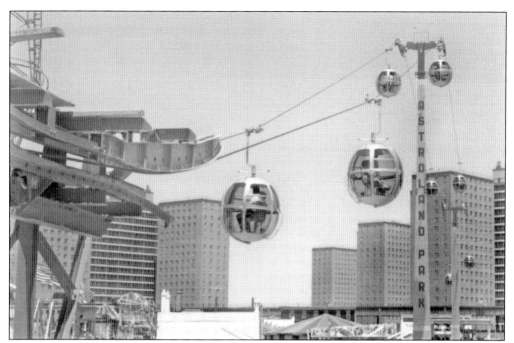

The Skyride, manufactured by Von Roll of Switzerland, opened in 1963 and was dismantled in 1975. (Courtesy of the Astroland Archive.)

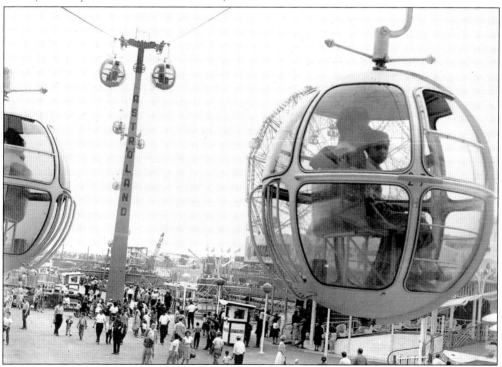

Although scary, the Skyride was not a thrill ride. The experience was more like floating quietly through space. The blue bubbles were quite beautiful, like lost balloons drifting across the Coney Island skyline. (Courtesy of the Astroland Archive.)

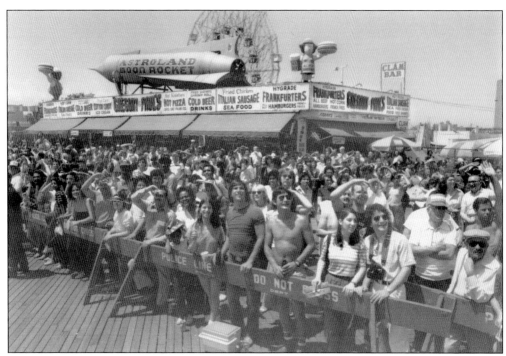

Air shows attracted some of Coney Island's largest crowds. During the 1980s, the three-day Golden Knights Air Show was the highlight of Coney Island's yearly Midsummer Festival. (Courtesy of the Astroland Archive.)

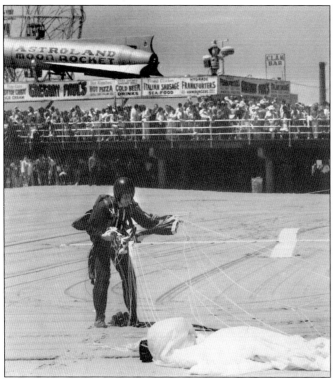

A skydiver gathers up his parachute on the beach in front of the Astroland Moon Rocket in 1979. Many crowd-pleasing special events such as air shows and festivals were sponsored by the family-owned Astroland Park and Deno's Wonder Wheel Park. (Courtesy of the Astroland Archive.)

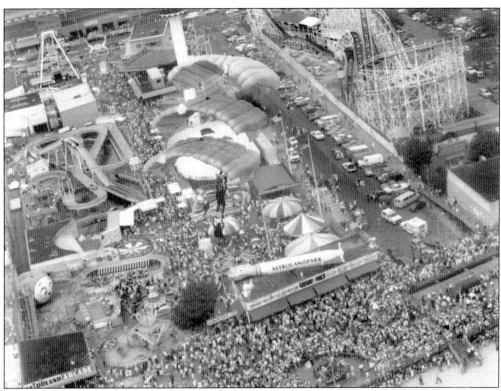

Skydivers float above Astroland while cruising in for a beach landing during a 1998 air show. (Courtesy of the Astroland Archive.)

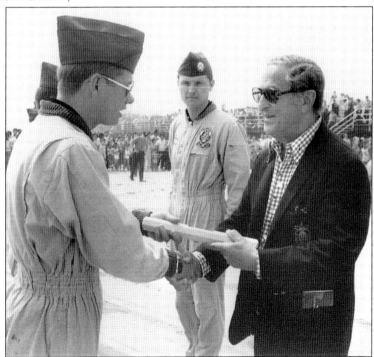

Dewey Albert is thanked for Astroland's sponsorship of the 1985 air show and is awarded a souvenir baton by a member of the US Army's Golden Knights Precision Parachute Jump Team. The Knights jumped from 13,500 feet onto a 10-foot-wide banner in the shape of a cross placed on the beach in front of Astroland. (Courtesy of the Astroland Archive.)

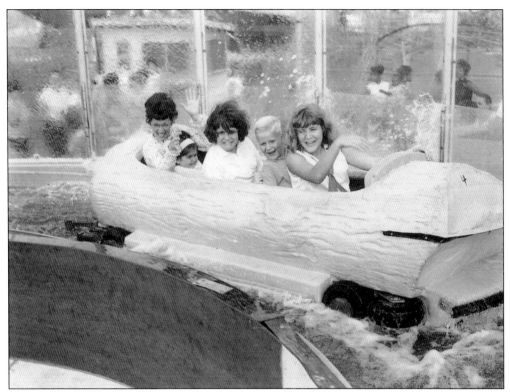

Water Flume riders were guaranteed a soaking, and that's what many came for. A see-through fiberglass barrier protected the midway from the ride's big splash finale. (Courtesy of the Astroland Archive.)

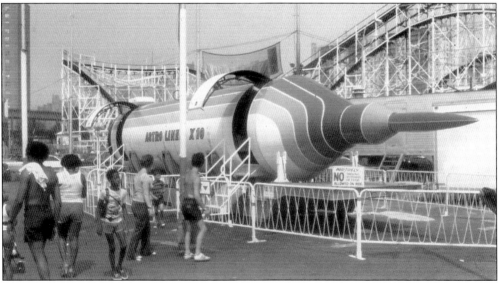

In 1972, Astroland moved the park's iconic Moon Rocket to a Boardwalk location on the roof above Gregory and Paul's Restaurant and brought in a new Astroliner. (Photograph by Abe Feinstein.)

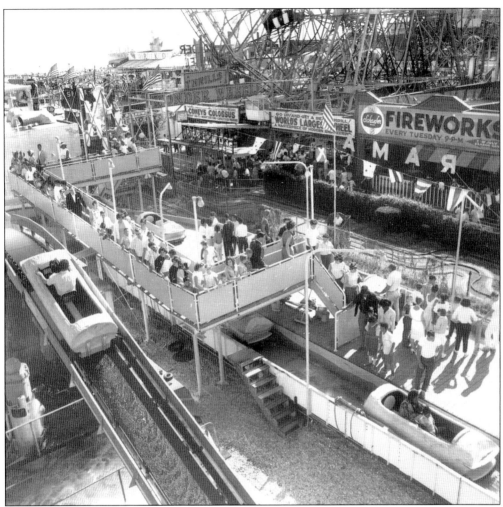
Astroland's most popular ride until its last days was the Water Flume, manufactured by Disneyland ride-designer Arrow Development Company, which operated the ride during the park's early years. (Courtesy of the Astroland Archive.)

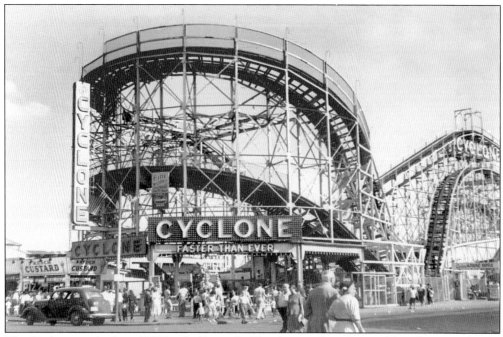

The Cyclone was built in 1927 by the Rosenthal brothers and was later sold to the Pinto family, who in turn sold it to the city. The city leased it back to the Pintos with the understanding that they could operate it until it was demolished for the Aquarium expansion. Maintenance was deferred, and the coaster fell into disrepair until it was leased to Astroland and restored to its former glory. (Courtesy of the Astroland Archive.)

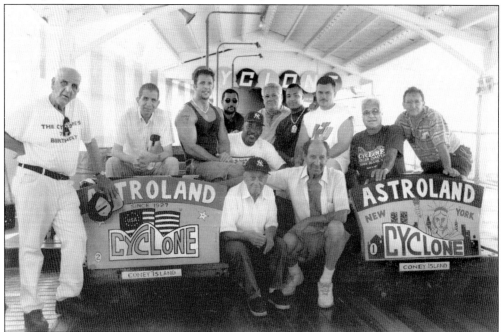

The Cyclone crew celebrated the coaster's 70th anniversary in 1997. (Courtesy of the Astroland Archive.)

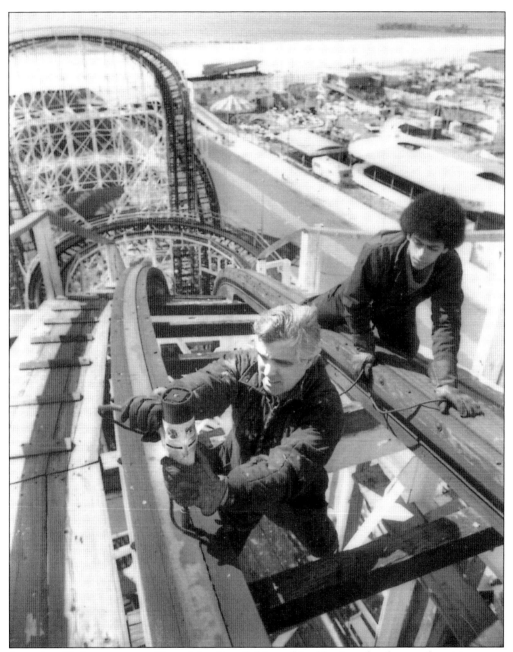

Longtime Cyclone manager Gerry Menditto (left) was hired by Astroland as an electrician soon after the park opened. His first assignment was converting the wiring of the European rides to American standards. When Astroland took over the Cyclone in 1975, Menditto was put in charge of renovating and rebuilding the structure. He remained at the helm as manager for the next 35 years. Although he was in charge of every aspect of the coaster's operation, he admitted that he had never ridden it. Menditto monitored the coaster by ear, claiming he could hear potential problems before they arose. (Courtesy of the Astroland Archive.)

Coney Island's West Tenth Street was renamed Dewey Albert Way in 1997 to honor Astroland's founder, who passed away in 1992. (Courtesy of the Astroland Archive.)

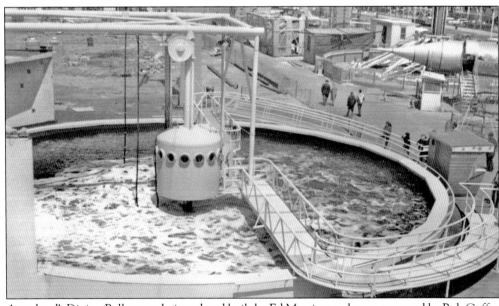
Astroland's Diving Bells were designed and built by Ed Martine and were operated by Bob Coffey and Bill Beck. Each bell had a microphone inside that broadcast the screams of riders as it shot to the surface and bounced in the waves. The ride remained on the midway until 1982. (Courtesy of the Astroland Archive.)

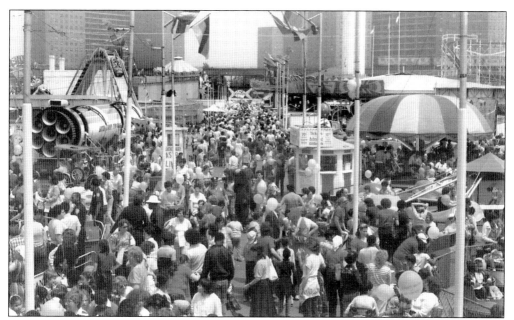

Astroland's midway in 1979 included the new Astroliner X-10 flight simulator. (Courtesy of the Astroland Archive.)

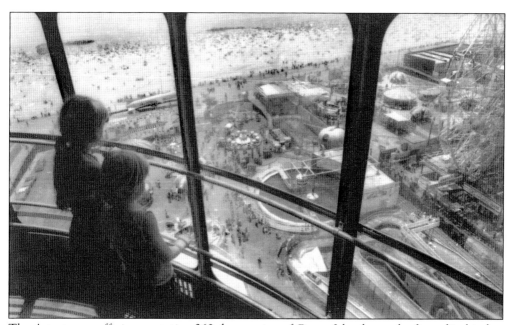

The Astrotower, offering a rotating 360-degree view of Coney Island, was the first of its kind to be built in the United States. (Courtesy of the Astroland Archive.)

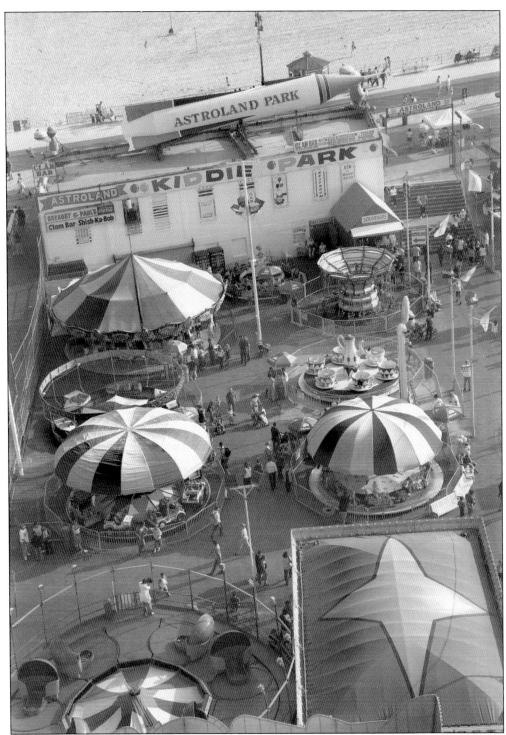

Among the rides at Astroland's kiddie park were a carousel, an Italian Big Apple Coaster, bumper cars, a Zamperla Tea Cup and Swing Ride, a Scrambler, a Tilt-A-Whirl, Mangels fire engines, a Frog Hopper, a Kiddie Himalaya, and a Circuit 2000. (Photograph by Charles Denson.)

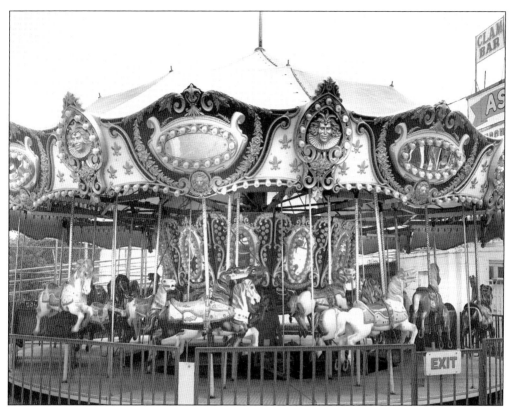

Astroland's Allan Herschell carousel was a beautiful machine that was completely rebuilt by the Chance Corporation. Herschell was a pioneer in creating slow-moving kiddie carousels with colorfully painted aluminum horses that children could ride without being accompanied by an adult. (Courtesy of the Astroland Archive.)

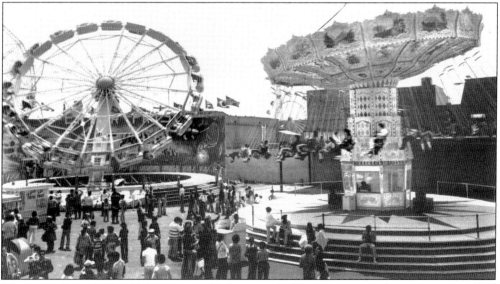

The Enterprise and Wave Swinger were added as part of a $2-million renovation of the park in 1976 after the Surf Avenue fire cleared the park's frontage. (Courtesy of the Astroland Archive.)

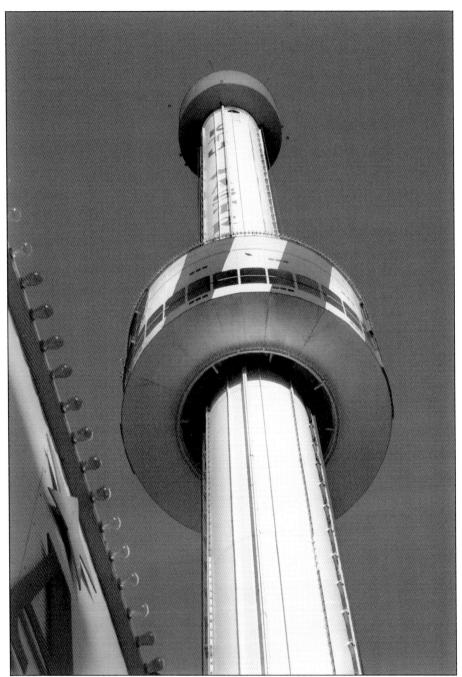

The Astrotower, known affectionately as the Flying Bagel, was designed and built by Swiss manufacturer Willy Buhler at a cost of $1.7 million. The foundation was composed of 1,100 tons of concrete reinforced with 13 tons of steel. When the wind blew from the southeast during storms, the tower swayed noticeably and the cables provided a distinctly mournful hum. Every December, the Albert family placed an enormous lighted Star of David at the top of the tower to celebrate Hanukkah. The Vourderis family still places a Christmas cross atop the Wonder Wheel. (Courtesy of the Astroland Archive.)

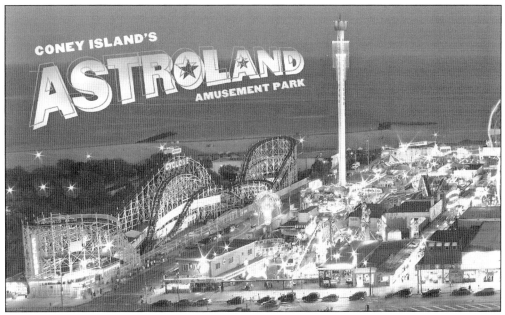

An Astroland advertisement from 2006 showed the park illuminated at night. (Photograph by Charles Denson.)

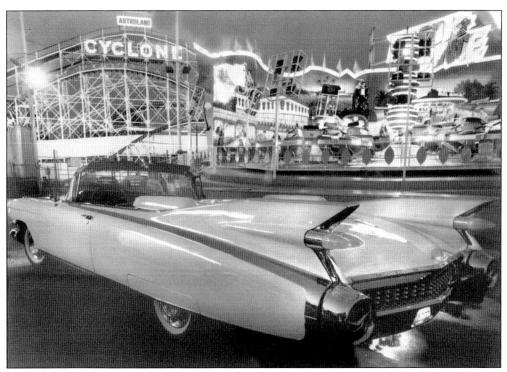

Jerry Albert's vintage Cadillac strikes a space-age pose in front of Astroland's Breakdance. The car was a regular entrant in Coney Island USA's Mermaid Parade. (Courtesy of the Astroland Archive.)

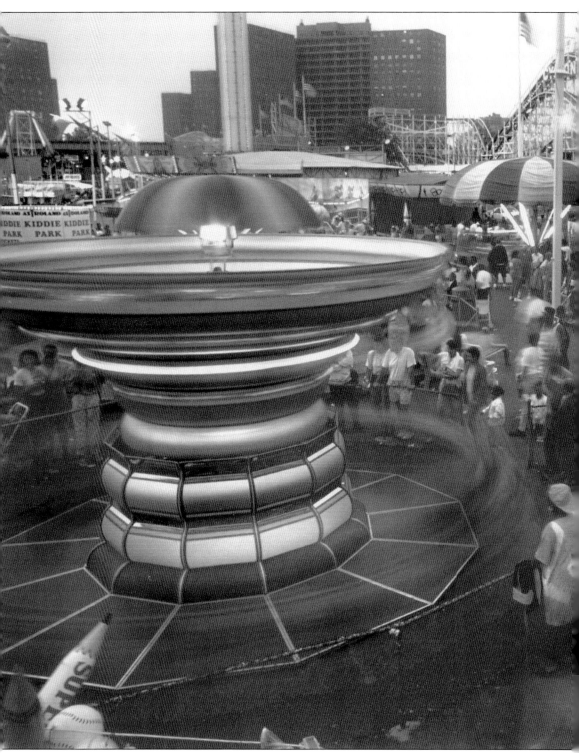

At dusk, Astroland's kiddie park became a kaleidoscope of spinning rides that included a carousel, boats, fire engines, motorcycles, trucks, bumper cars, teacups, and swings. (Courtesy of the

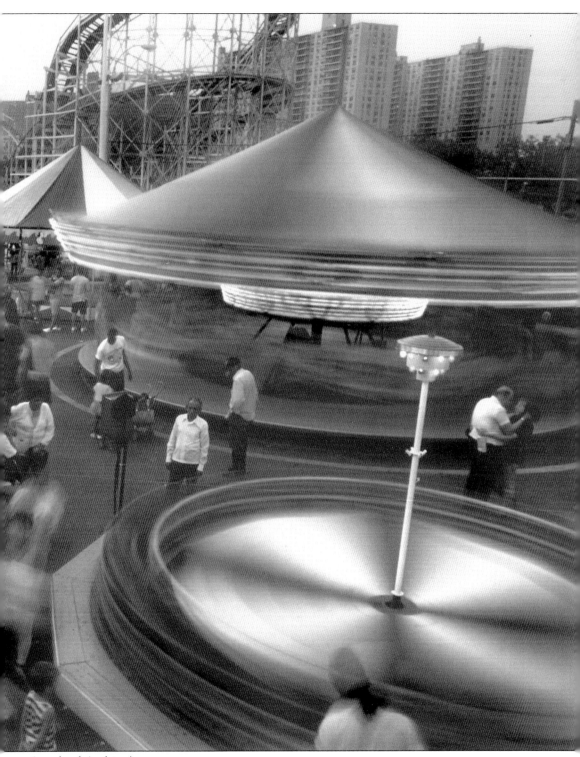
Astroland Archive.)

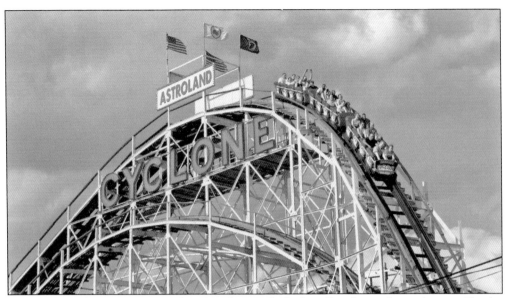

The Cyclone's heart-stopping 85-foot first drop is clocked at 60 miles per hour. Aviator Charles Lindbergh rode the Cyclone in the 1920s and called it the scariest ride he had ever experienced. Below the hill can be found wigs, false teeth, wallets, cell phones, and a variety of hats lost by riders who neglected the signs to check them at the platform. (Photograph by Charles Denson.)

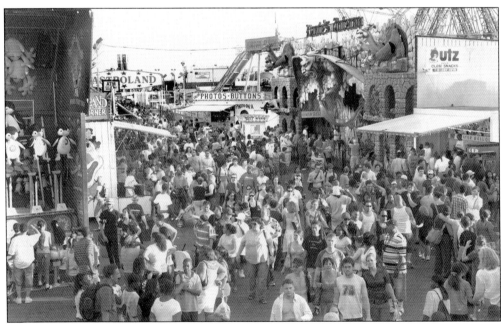

Astroland's midway was always crowded on a hot summer day, drawing visitors from Surf Avenue to the Boardwalk. The park's undivided three acres represented the last of the original beachfront land grants made by the town of Gravesend in the 1870s. (Photograph by Charles Denson.)

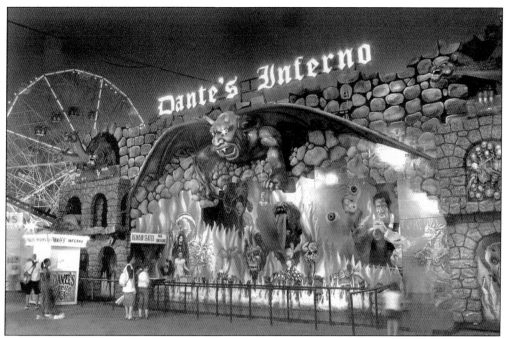

David Letterman once interviewed riders exiting Dante's Inferno and asked which they liked better: the ride or the book. (Photograph by Charles Denson.)

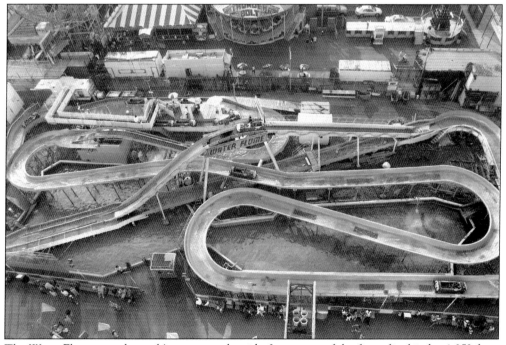

The Water Flume was the park's most popular ride. It was one of the first of its kind, a 1,052-foot-long whitewater glide in fiberglass logs through a series of twists and turns into a soaking wet splashdown in front of spectators on the midway. (Photograph by Charles Denson.)

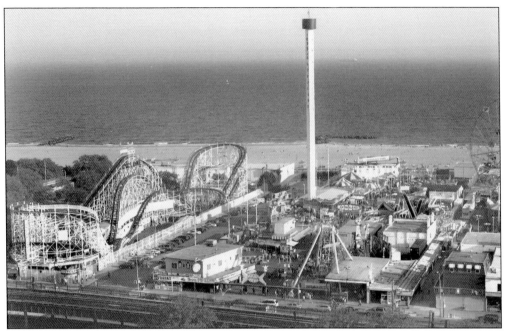

Astroland had the ideal location, between the beach and the subway. The Albert family made numerous unsuccessful proposals to the city for closing West Tenth Street (which bisected the park and the Cyclone) and using the land to connect and expand the park. (Photograph by Charles Denson.)

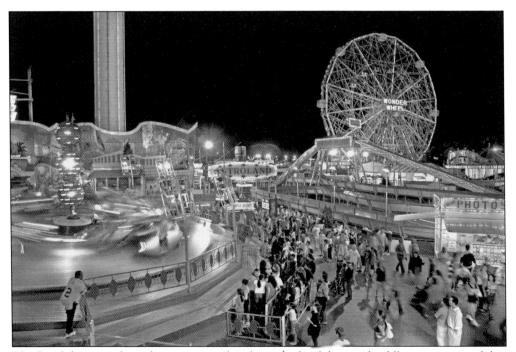

The Breakdance, with its thumping soundtrack, strobe-lit globes, and wildly spinning gondolas, provided a heavy beat for the midway. (Photograph by Charles Denson.)

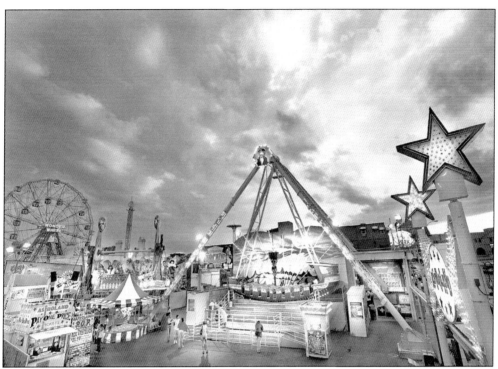
The Pirate Ship is lit up after a thunderstorm. (Photograph by Charles Denson.)

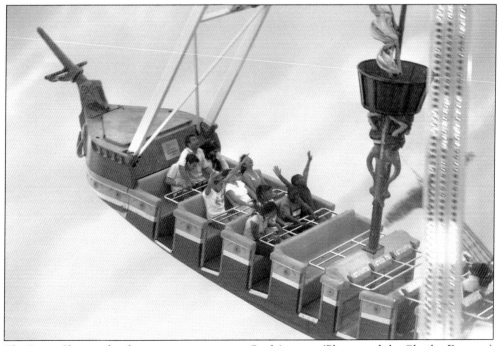
The Pirate Ship made a heart-stopping arc over Surf Avenue. (Photograph by Charles Denson.)

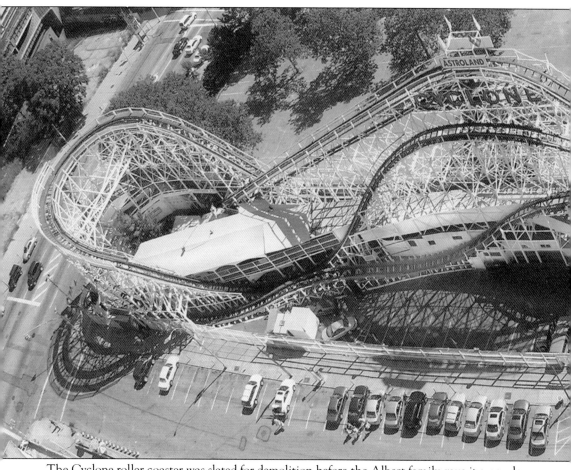

The Cyclone roller coaster was slated for demolition before the Albert family gave it a new lease on life. Immediate repairs and upgrades costing $120,000 enabled the ride to open for the 1975 season, and millions more were spent by the Alberts to keep the coaster in operating condition. The ride became a New York City Landmark in 1988 and a National Historic Landmark in 1991. The Cyclone may not be the largest coaster in the world, but many consider the rickety wood-and-steel ride to be the most famous as well as the scariest. It was designed and built in 1927 by Vernon Keenan and Harry C. Baker. The 1-minute, 50-second ride is 2,640 feet in length, has a

Gerry Menditto, the man at the controls of the Cyclone roller coaster for four decades, was responsible for the inspection, repair, and operation of Coney Island's most famous ride. (Photograph by Charles Denson.)

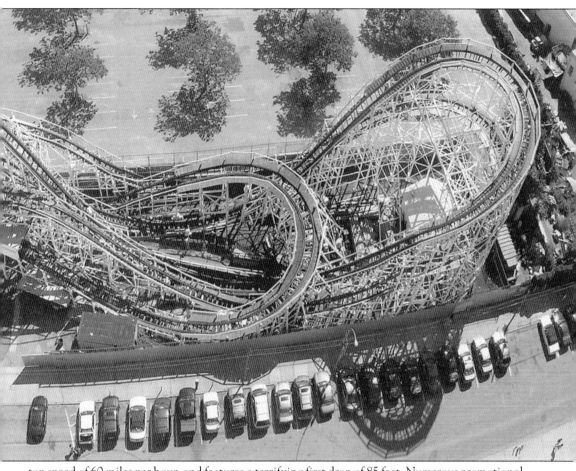

top speed of 60 miles per hour, and features a terrifying first drop of 85 feet. Numerous promotional events took place on the ride, among them running the coaster backward during the 1984 season to celebrate the centennial of the Switchback Railway, the world's first roller coaster, and a 104-hour marathon ride in 1977 by Richard Rodriguez. The Cyclone's 70th birthday in 1997 was celebrated by Tino Wallenda's tightrope walk between the coaster's high points. (Photographed by Charles Denson.)

The Cyclone operations crew had many duties: restoring the cars, walking the tracks, and operating the passenger platform. During the winter, the crew rebuilt the coaster's cars in a shop located below the ride's tallest hill. (Photograph by Charles Denson.)

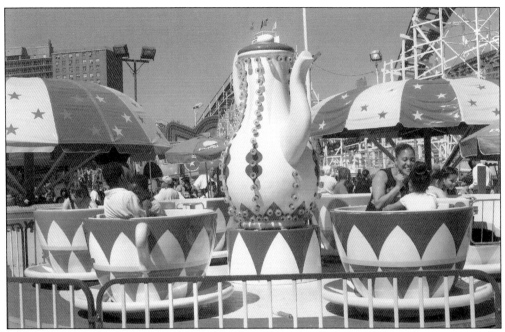
The Tea Cup kiddie ride was a late addition to Astroland's lineup. The ride was originally introduced at Disneyland in 1955. (Courtesy of the Astroland Archive.)

Circus Day was one of numerous special events held at Astroland throughout its history. Over the years, a variety of music filled the park, from Murray the K Rock 'n' Roll Shows in the 1960s to hip-hop concerts in the 1990s. (Courtesy of the Astroland Archive.)

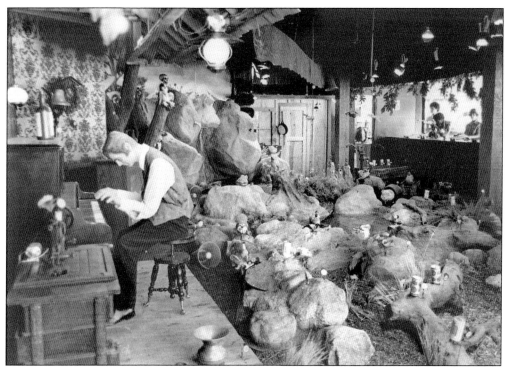

One of the park's nostalgic fixtures was the vintage Bonanza Shooting Gallery. The attraction was located on Surf Avenue below the Astroland offices. The rifles used photoelectric cells instead of bullets. (Courtesy of the Astroland Archive.)

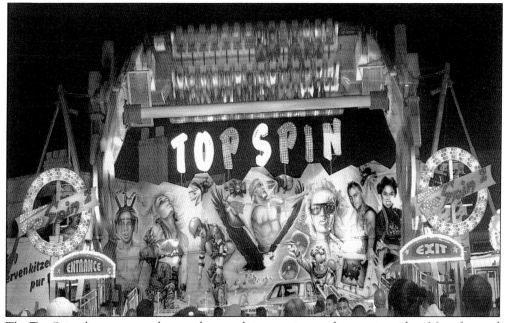

The Top Spin always attracted a crowd to watch its gyrations and screaming riders. Manufactured by HUSS, the looping thrill ride had a soundtrack and a "hang time," during which the gondola was held upside down while water jets soaked the riders. (Courtesy of the Astroland Archive.)

Astroland's Astrogirls prepare for the 2008 Mermaid Parade. Astroland sponsored a float every year as well as providing major contributions to the parade's operation. (Photograph by Charles Denson.)

At an Astroland ceremony, Carol and Jerry Albert were presented an award by 60th Precinct commander Charles Scholl for their charitable work with the New York City Police Department's Anchor Club, which benefits widows and children of police officers. (Courtesy of the Astroland Archive.)

Longtime staffers Carole O'Donnell (left) and Lois Colin (right) pose with Miss Cyclone, Angie Pontani, and Carol Albert. (Photograph by Charles Denson.)

Carol Albert and Astroland manager Mark Blumenthal (at right) worked on a redesign of the park with an architect shortly before the decision was made to sell the property. (Photograph by Charles Denson.)

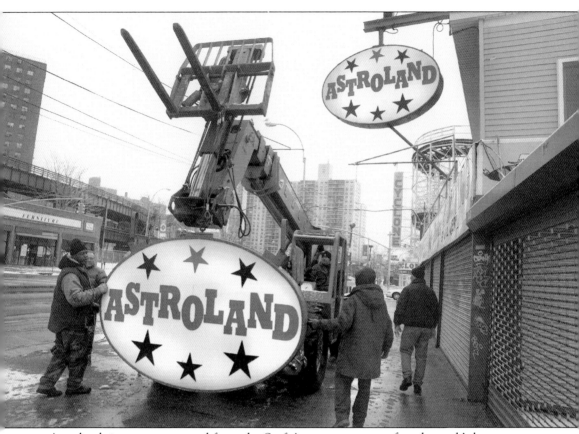

Astroland signs were removed from the Surf Avenue entrance after the park's lease was not renewed and it was forced to close for the 2009 season. The signs were placed in storage, along with most of Astroland's rides. (Photograph by Charles Denson.)

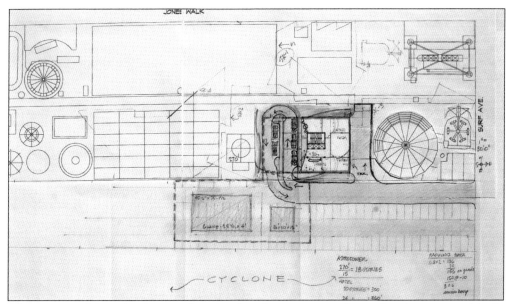
The owners of Astroland wanted to develop their property themselves but received little encouragement from city agencies responsible for the rezoning of the amusement area. This preliminary plan, drawn up in 2006, proposed that a hotel and a decked parking structure with amusements be added to the park's layout. (Courtesy of the Astroland Archives.)

On September 4, 2008, Carol Albert informed employees that the park's lease had not been renewed and the park would be forced to close. (Photograph by Charles Denson.)

Astroland employees gathered on the steps of the park's Boardwalk entrance to pose for a final photograph on closing night. A party at Ruby's Bar followed the closing. (Photograph by Charles Denson.)

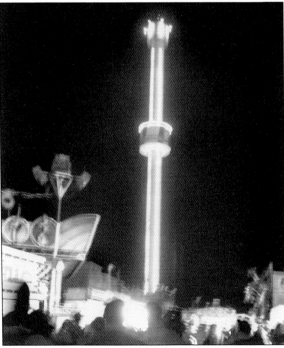

Astroland's rides were switched off and darkened one by one as the employees walked slowly through the park from the Boardwalk to Surf Avenue. The Astrotower was illuminated for the last time as the observation car slowly descended to the ground. Then the park went dark forever. (Photograph by Charles Denson.)

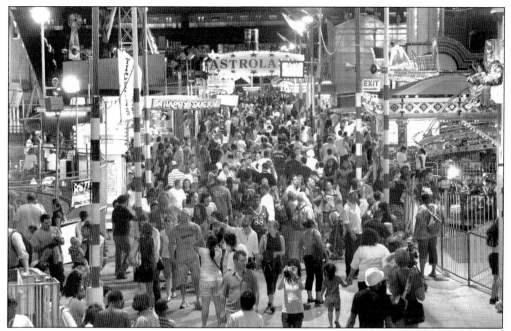

A large and emotional crowd gathered on the midway to say goodbye to Astroland on closing night. Thousands had passed through the park during the day, and later that night, security guards had to clear the park of patrons who refused to leave after closing time. (Photograph by Charles Denson.)

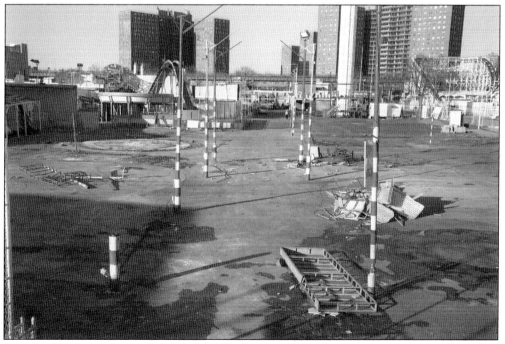

Astroland Park was dismantled and cleared by January 2009. The Astrotower remained standing though inoperable. The city bought the property and leased it to Central Amusements International, an offshoot of Italian ride manufacturer Zamperla. (Photograph by Charles Denson.)

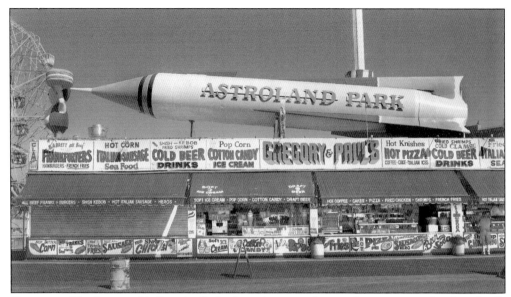

Gregory and Paul's venerable Boardwalk food stand remained a popular attraction after Astroland's closure. When Gregory retired and the pair's 50-year partnership ended in 2008, Paul changed the name of the stand to "Paul's Daughter" and continued operating with his daughters in charge. (Photograph by Charles Denson.)

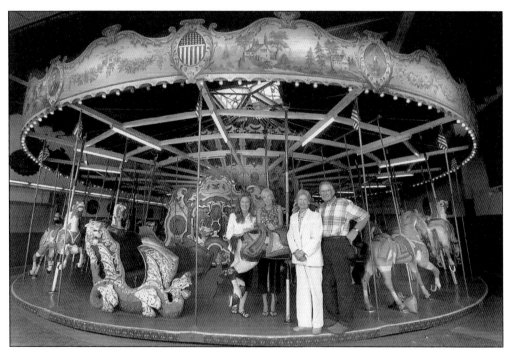

In 2005, the McCullough family posed on the B&B Carousell on the day that it was bought by the city for $1.8 million, believed to be the highest price ever paid for a carousel. Tilyou descendant Jimmy McCullough and his daughters continued to operate the family's Bowery Kiddie Park after the sale. (Photograph by Charles Denson.)

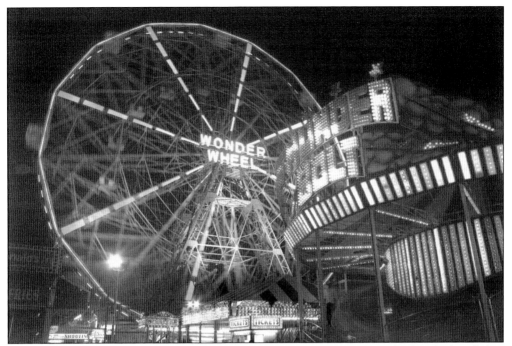

The last family-run amusement park in Coney Island is Deno's Wonder Wheel Park, founded in 1981 and operated by the Vourderis family. The park has 22 rides, including a classic Tilt-a-Whirl and antique Mangels fire engines. Below the wheel is the famed Spook-A-Rama, a classic kitschy 1950s dark ride. (Photograph by Charles Denson.)

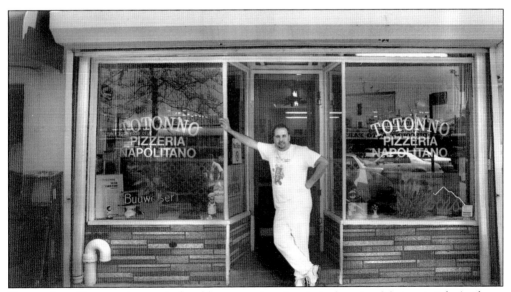

Totonno's on Neptune Avenue is the oldest operating pizzeria in America. Master pizziola Anthony "Totonno" Pero opened the Coney Island restaurant in 1924, and four generations of his family have run it ever since. Totonno's still uses a coal-fired brick oven to bake its famous pizza pies, made from a secret recipe and often rated the best in New York. (Courtesy of the Coney Island History Project.)

The Fitlin/Buxbaum family, owners of the Eldorado Skooter and game arcade, has operated businesses on Coney Island's Bowery for nearly a century. The skooter ride's famous slogan is "Bump, bump, bump your ass off!" (Photograph by Charles Denson.)

Frankfurter fans clogged the streets in front of Nathan's Famous for the annual Fourth of July Hot Dog Eating Contest in 2009. Joey Chestnut won his fourth title by eating 54 hot dogs and buns in 10 minutes. (Photograph by Charles Denson.)

A float in the 2010 Mermaid Parade paid homage to Astroland and the Parachute Jump. The parade was founded in 1983 by Coney Island USA and is a contemporary version of Coney's Mardis Gras, a yearly event that ran from 1903 until 1954. (Photograph by Charles Denson.)

Astroland's Moon Rocket stood alone on the deserted midway shortly before being donated to the city by the Albert family. The rocket was removed by crane from its rooftop perch and trucked to a storage yard in Staten Island, where its fate remains unclear. (Photograph by Charles Denson.)

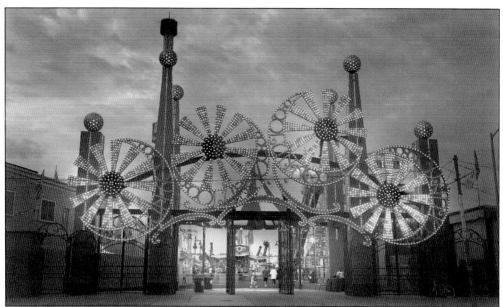

The city purchased the three-acre Astroland site in 2009 and leased it to Central Amusements International, an offshoot of ride-manufacturer Zamperla USA. A new amusement park named after Coney's original Luna Park opened on the site in May 2010. (Photograph by Charles Denson.)

The nonprofit Coney Island History Project sponsors activities and programs that document Coney Island's colorful past and encourages appreciation of the Coney Island neighborhood of today. The CIHP records, archives, and shares oral history interviews; organizes exhibitions, lectures, and performances; and honors community leaders and amusement pioneers through the Coney Island Hall of Fame. Emphasizing community involvement, the CIHP teaches young people the importance of oral history and develops programs in conjunction with schools, museums, and other organizations. The CIHP's free public exhibition center displays historical and contemporary photographs, artwork, artifacts, maps, books, and films. Exhibits have included Secrets of Coney Island Creek; Woody Guthrie: The Coney Island Years; and Land Grab: A History of Coney Island Development. Visitors are invited to share their memories of Coney Island and bring in family photographs to be scanned and added to the growing CIHP archive. For more information, go to www.coneyislandhistory.org. (Courtesy of the Coney Island History Project.)

Discover Thousands of Local History Books Featuring Millions of Vintage Images

Arcadia Publishing, the leading local history publisher in the United States, is committed to making history accessible and meaningful through publishing books that celebrate and preserve the heritage of America's people and places.

Find more books like this at
www.arcadiapublishing.com

Search for your hometown history, your old stomping grounds, and even your favorite sports team.

Consistent with our mission to preserve history on a local level, this book was printed in South Carolina on American-made paper and manufactured entirely in the United States. Products carrying the accredited Forest Stewardship Council (FSC) label are printed on 100 percent FSC-certified paper.